Karenni

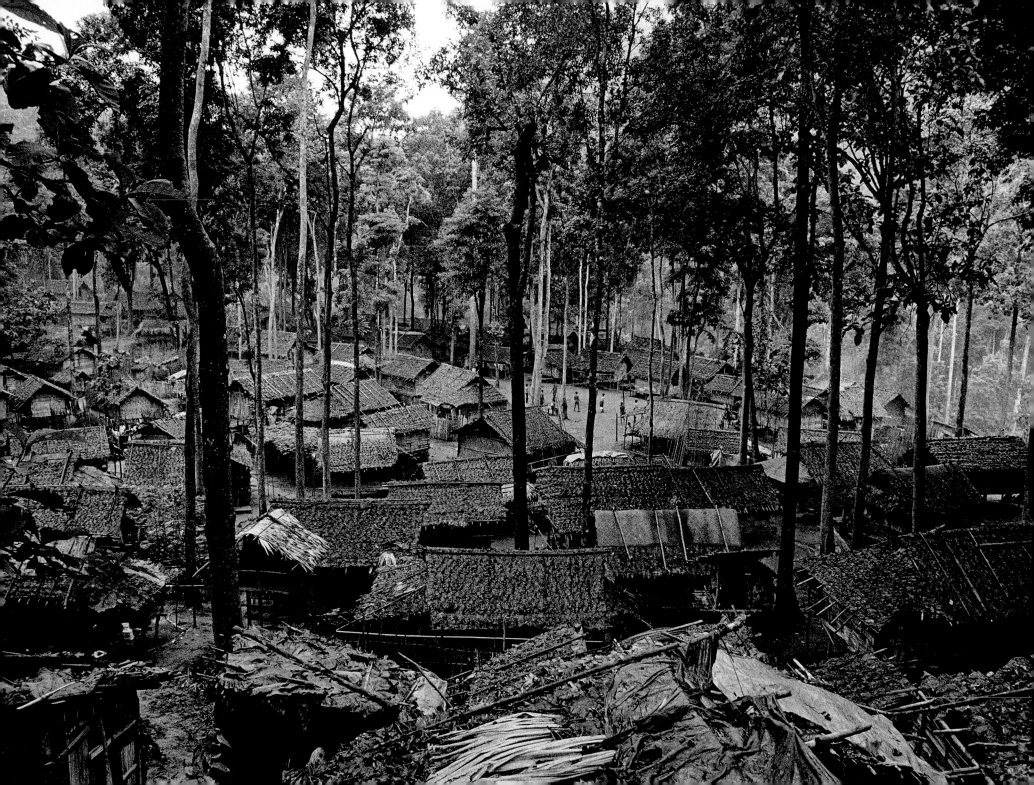

DEAN CHAPMAN
KARENNI

DEWI LEWIS
PUBLISHING

To my parents Maureen and Dave

I would like to thank Shey Reh, Oo Reh,
Klaw Reh, Aung Than Lay, Donald,
David Saw Wah, Rimond Htoo, Abel Tweed,
Sonny Mohimder Singh, Htain Lin,
Hte Bu Peh, Pah Bu, La Bur, Moo Pow,
Byar Reh Paulu, Michael, Shar Reh,
Aung Myat, Luka, Htuh Reh, Plyar Reh,
Doh Say, and the late Saw Maw Reh
for their complete support in making
this work possible. I would like to thank my
brother David Lee Chapman who has made
a significant contribution in making this work
possible. There are many people who let me
into their lives without question
or doubt and offered hospitality, friendship
and understanding; to them I am sincerely
grateful. My hope is that their struggle
for self-determination, democracy and peace
will be truly successful, that their suffering
will cease and that they will be able to return
home to their farms and villages to
establish a free Karenni State.
deh bwi, de re banah, Kuh Di Reh

European Publishers Award for Photography 1998
Fifth edition

Jury

Giovanna Calvenzi
Photo editor "Lo Specchio della Stampa"

Dewi Lewis
Dewi Lewis Publishing

Günter Braus
Umschau/Braus

Eric Hazan
Éditions Hazan

Andrés Gamboa
Lunwerg Editores

Mario Peliti
Peliti Associati

in collaboration with

 LEICA

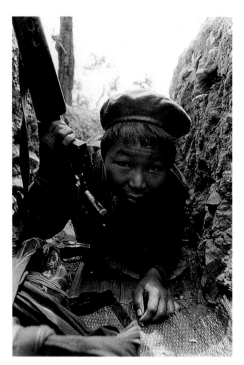

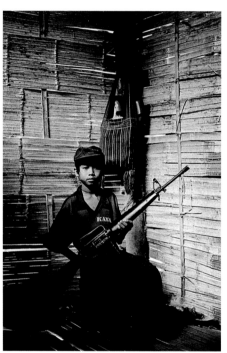

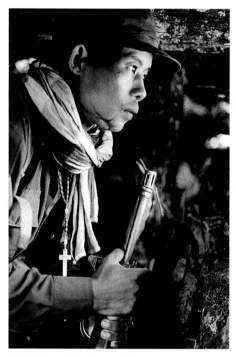

Antonio taking cover in a trench as Burmese Army mortar shells rain down on the hilltop position.

A 9 year-old Karenni guerrilla with an M16.

A lull in the artillery barrage. A Karenni guerrilla staring from a bunker, anticipating the Burmese Army's ground offensive during the second battle for Ember Hill.

"One shot, one kill, no fear." Antonio's fighting abilities were beyond doubt. The thirteen-year-old "killed at least three Burmese soldiers in the fighting and didn't waste a shot." His toothless CO was clearly pleased with the teenager's discipline during battle. Antonio was proudly wearing the blood-splattered bush hat of the young Burmese soldier he picked off in the initial battle for Ember Hill. With schoolboy vigour, the baby-faced Catholic happily acted out the exchange of fire in which he shot his enemy dead between the eyes. He said he wasn't afraid.

Antonio had already been a soldier in the Karenni Army for a year prior to the battle. His reasons for wanting to fight were unequivocal; "I want revenge. The Burmese Army forced my family and the people of our village into a concentration camp at gunpoint." They were victims of forced relocation; a strategy ruthlessly implemented by the Burmese Army and aimed at wiping out popular support for the Karenni Army. Thousands of civilians, mostly Christians, were forced at gunpoint from their homes and into internment camps. Others escaped to relative safety along the Thai border, walking for weeks in the unrelenting heat of the dry season, over formidable mountain terrain. As vast tracts of countryside were emptied of civilians, the vacated area became a free fire zone; anyone found there was considered a terrorist and executed. Villages were systematically looted by Burmese soldiers, then razed to the ground.

When Rangoon's troops arrived to give notice of the relocation of Maria's village, they forced the terrified villagers into their Catholic Church; the statue of the Virgin Mary was smashed, pictures of Jesus were torn up and the pastor's robes confiscated. They were told they would be shot if they failed to relocate within a week. Maria decided to join other petrified villagers fleeing to Thailand. "We had no food and sometimes no water," recalled the fifty-year-old Kayaw grandmother, "and I thought the Burmese would kill me. One of my grandsons and one granddaughter died [in an internment camp] because of a lack of medicine and treatment." Her sister died on the way to Thailand. Maria had previously experienced brutality at the hands of the Burmese military. Her nephew died after being taken to porter for the Burmese Army, "he received no food and ate only leaves. He got sick and died from dysentery. It was his first time as a porter. He left a wife and two children."

Wrapped up in one half of a grubby, threadbare blanket, Antonio slept restlessly through the painfully cold nights curled up on a rice sack in a narrow trench. Other anxious combatants bedded down over smouldering campfires, the smoke keeping irritating mosquitoes at bay. Watchful sentries patrolled the vulnerable hilltop positions, their torchlights seeking out any unusual sounds or activity from the hillsides below.

"BANG, BANG, BANG." Who's shooting? Immediate adrenaline, pumping hard and fast. Everybody's up. Dashing breathlessly into position. Weapons at the ready. Peering into the inky darkness. "BANG, BANG." Vivid green and red tracers, piercing the night. Spitting down the hillside opposite. "BANG, BANG, BANG." The walkie-talkie crackles. What's happening? What's going on? An attack? What are they saying? Something moved down by the wire? A shadow moved? And then silence. Blood rushing.

Ember Hill reeked. The stench of death lingered ominously in the air. The hillsides around the positions were littered with dead government soldiers. Karenni medics tried to burn the nearby corpses, but rain extinguished their efforts. A meagre diet of rice and yellow bean soup filled the hungry stomachs of the fighters, but the flavour came from all around. At night, sentries killed jungle rats with deadly slingshot fire, but there were never enough rodents to go around. Giant red centipedes, frogs, tiny freshwater fish and crabs were occasionally caught and voraciously eaten. Fried with dried chillies, Antonio devoured the bee larvae from a hive he found in the hollow trunk of a felled tree.

All of the trees on Ember Hill were felled so that mortar shells would not explode

overhead, as had happened in the first battle. The ridges and approaches to the positions were cleared of vegetation to improve visibility and minimise cover for the encroaching enemy. Bunkers were constructed by laying the trunks of the felled trees over large pits. More trenches were chiselled out of the hard, rocky earth. Barbed wire perimeter fences were erected around the positions and countless home-made mines laid outside them. This time round the Karenni Army and the All Burma Student Democratic Front soldiers would be ready for the Burmese offensive.

Karenni guerrilla cells had been attacking the Burmese forces repeatedly during the build-up. A deafening explosion in the valley below Ember Hill shattered the tranquillity of a dreary grey morning. All that could be seen was a cloud of thick white smoke mushrooming out of a sea of lush green. Karenni troops had detonated a chain mine along a jungle trail, on which a Burmese section was patrolling. Stones and home-made explosive had been packed into old plastic soap dishes and wired together. Once buried, the hidden snake awaited its prey. With the enemy wandering over the sleeping beast, a lone fighter connected two wires to either end of a dry cell. Hurtling razor-sharp plastic splinters, rock and dirt, annihilated the unsuspecting enemy.

A few days previously, Karenni resistance fighters had ambushed another enemy section on a ridge opposite. For forty minutes, Rangoon's forces were pinned down beneath a barrage of rocket-propelled grenades and relentless automatic fire. They were overwhelmed in an indefensible position. Spiteful screams of support echoed from the hilltops, ablaze with verbal retribution. When it was all over, four Karenni guerrillas disappeared into their brother jungle.

"DEMOCRACY, WHERE DO YOU GO?" "DEMOCRACY, I DON'T UNDERSTAND." Standing atop a barricade, Moses hollers despairingly, both fists punching the air. But there's no reply. Only a lull in the shelling as the Burmese Army eats lunch. The dust settles. A warming sun beats down. The Karenni and ABSDF combatants emerge into an eerie, mocking silence. For hours they have been cowering in crowded bunkers, scurrying around narrow trenches, unable to fight back until the ground offensive begins. The tension is thick, palpable. Some vent their pent up frustration by bellowing obscenities at the unseen, enclosing enemy. Others suck thoughtfully on cigars, pondering on the green serenity and hushed calm of the stunning hills that surround them. Uncertainty stares back. When the bombardment initially began there had been overwhelming relief that the long wait was finally over, but that quickly vanished.

"BOOM, BOOM, BOOM." The shelling resumes in earnest. Everyone retreats underground. Dozens of shells are raining in. Impacts directly overhead. Dirt pouring in to the bunkers between the overhead logs. The waiting continues underground and the strain builds.

SUDDEN PAIN. A shrill cry soars between the deafening impacts, then falls to a grim whimper. Somebody's hit. A distressed CO frantically drags an injured soldier along the trench to the sheltered cooking area at the rear of the position. It's pandemonium.

Spotting the sudden activity through clouds of lingering dust, the Burmese artillery opens up resolutely, filling the heavens with keen deadly metal, and hot choking dust. Through the barrage, four stumbling comrades, one on each limb, scarper towards the rear position along an exposed ridge. Automatic fire rages behind them. The Burmese forces are approaching, closing in. Mortar shells descend indiscriminately on all combatants, obliterating the unlucky. The wounded soldier is lugged into a cramped bunker. His eyes are rolling. He's drifting in and out of consciousness. Two dismayed medics, pleading silently for divine assistance, wrestle with needles, bottles and bandages, desperately trying to keep him alive. Where's he hit? His dirty camouflage shirt is cut away. There's blood all over his crotch. No, the wound is in his back. He's having trouble breathing, blabbering on like a child, "the Burmese are coming, the Burmese are coming". A blanket is tied hammock fashion from a thick length of bamboo and the injured soldier placed inside, hollering in pain. Today had been his turn to return to the rear for a day of rest and recreation.

But now he is being carried there in distraught haste, away from the battlefield, along a precarious track with darkness falling. It's desperate. Adrenaline bleaching out all thought, and instinct taking over. Speed means life. It takes well over an hour to haul the wounded fighter back to Rambo Hill on the border. Laid out and covered in blankets in the back of a pick-up truck, the young soldier is unconscious. The vehicle is soon bumping down the mountainside following an uneven logging track into Thailand; a delirious hour every inch of the way rough and jarring. Then the paved highway and hurtling at breakneck speed. Overtaking all other traffic. Eyes streaming as the freezing wind rips past in the back, the wounded soldier lying motionless, the blankets sodden with blood. The fluorescent lights of Mae Hong Son hospital are dazzling.

The second battle for Ember Hill began with a ferocious artillery bombardment in which twelve hundred shells pummelled three Karenni positions. On the third day of the offensive, hundreds of Burmese troops began the ground assault. With their limited supply of ammunition quickly exhausted, the resistance fighters tactically withdrew under cover of darkness, leaving behind dozens of landmines and booby-traps for Rangoon's forces. Karenni combatants later spoke of wiping out entire sections of the enemy with rocket-propelled grenades. Antonio survived unscathed and cocky, claiming another three kills. The mastermind behind the Burmese Army's offensive, Colonel Maung Kyi, later admitted that the forces under his command sustained over a thousand casualties in the operation. A third are believed to have perished. Their deaths went unreported.

A war of resistance has been waged in the Karenni since Burmese forces invaded on August 8, 1948, seven months after Britain granted the Union of Burma independence. The Karenni had never been incorporated into the colony of British India, unlike Burma, and had enjoyed independence until occupation by the Japanese Imperial Army in 1942. Over the final months of the Second World War in Asia, the guerrilla activity of the Karenni and Karen spider levies, with the assistance of the legendary Allies' Force 136, were instrumental in defeating the Japanese. After the war, the Atlee Government, with the contrivance and duplicity of Burman representatives, rewarded Karenni support and sacrifice by incorporating the nation into the Union of Burma, where it has since been renamed the Kayah State.

On the evening of January 2nd, 1997, a significant number of Rangoon's soldiers crossed the border at Rambo Hill, and stole silently into Thailand. They nonchalantly passed a Thai outpost that may well have been unmanned, and followed an old logging track down to the unprotected, sleeping refugee camps. They stealthily took up positions on a low hill overlooking the tiny bamboo huts of Karenni and ABSDF families, nestling closely together on the steep inclines of a narrow gorge. Shortly after 2am the intruders opened fire; mortar shells exploded indiscriminately between the shelters, blasting through the flimsy walls. Automatic fire sprayed the camp as petrified refugees scrambled down the hillsides through the undergrowth. The darkness and rugged terrain of the landscape conspired to shield most of the refugees. As his wife and two children fled at his side, Ai Pun was cut down in a hail of bullets. Ei Pyin died in her sleep; butchered by huge chunks of grenade shrapnel tearing through her body. Ten other refugees were wounded. The gunmen escaped back across the border unchallenged.

On a balmy summer's evening in May '97, Plyar Reh Paulu, the Karenni Government's Minister for Religious Affairs, was watching TV at home, in the company of a house full of local children. Around eight o'clock he sent his guests home. The generator was playing up and the picture quality poor. Paulu, a grandson of a Karenni prince, was lying on an open veranda when a mortar shell smashed through the roof, exploding in a nearby bedroom. He shot up, scrambling for cover. Automatic fire raged and he felt a sharp pain just above his left elbow. He'd been hit. His eleven-year-old daughter ran to the front door. As she was about to escape,

a bullet struck her in her left side, passed through her stomach and exited from her right side. She collapsed. Paulu picked her up and ran for cover. He waited, and listened carefully. As the assassins escaped into the darkness, he put his daughter into the back of his car and sped to Mae Hong Son hospital. The eleven-year-old underwent major surgery and survived, but was left with two four-inch-long scars on her stomach. It's unclear whether she'll be able to bear children.

Christopher didn't experience much of a childhood. He was ten years old when he joined the Karenni Army. His hatred of the Burmese is deep-seated; "The Burmese soldiers came across my father while he was walking on the road. They stole his watch, money and gold wedding ring. He was ordered to carry four 81mm mortar shells. The load was too heavy for him. He had undergone a major stomach operation two months before. He eventually collapsed. The soldiers began punching and kicking him, calling him a 'Karenni terrorist'. They hit him with their guns, and stabbed him with their bayonets. The other porters were ordered to dig a big hole. My father was thrown in it and buried up to his neck. My uncle, who had also been taken as a porter, witnessed everything. He was released two days later and returned to find my father dead." At that time, Christopher's family had no contact with the Karenni resistance movement. Of five children, Christopher and his elder brother have joined the Karenni Army. One sister became a maths teacher in a Karenni Government school, while another married a Karenni soldier. The abuse of civilians, forced at gunpoint to carry munitions and provisions for the Burmese Army, often into life threatening situations, is an everyday occurrence in the Karenni.

A score of farmers who were forced to carry ordnance to the front line, escaped by fleeing through minefields to Karenni lines, and were said to have been "walking with the angels" by one local officer. It was miraculous that no one had been killed. The men were malnourished and traumatised, having been away from homes for more than two months. Some had been drinking in a teahouse when the Burmese Army randomly detained them, while others had been taken from a videohouse. Their incarceration began in a football stadium. Moved to a windowless jail where the latrine was no more than a plastic bag, they were permitted to buy food and water from the wives of soldiers. Disease was rife. Come the offensive, they were trucked to the border area and forced to carry mortar shells. At night they were bound together like animals. They were seldom fed. Unknown numbers of less fortunate porters died from malaria and dysentery, while others were beaten to death for tardiness, or for not understanding Burmese.

Bi Ya, a Kayaw Catholic, first ran away to join the Burmese Army when he was twelve years old because his family was poor and the army accepted young recruits. His father brought him home. At fourteen he tried again. During training he was treated roughly; regularly beaten, and poorly fed. He eventually became a Military Policeman and was stationed at Chaungzon in Mon State. He witnessed first hand the injustice and viciousness of the Burmese authorities. "Both the police and the army are involved in gambling and drugs trafficking. They are bought off. They find safe routes for drug traffickers, running white, black and green opium as well as amphetamines. The soldiers are very proud. When they get drunk, they steal and rape if given the opportunity. One soldier raped a girl and we arrested him. His captain came and took him away, saying that he would punish him but nothing happened. The army heard of Mon rebels patrolling through several local villages, and accused the villagers of supporting the rebels. Thirty-eight people were arrested and taken directly to a military court. A lawyer was called to represent eight people who could afford it. They were released that same day, while the other thirty villagers were each sentenced to three years imprisonment." "Civilian forced labour was used to build monasteries, pagodas, and roads, as well as cleaning the army camp. They were also forced to inform on others and act as spies. Prisoners, especially women, had to break rocks and cut grass using their bare hands. Political prisoners were always kept indoors. There were around seventy-five prisoners in our army

camp and over half were political prisoners. They were given little food". Torture was an everyday occurrence. "A thick plastic cover was placed over the detainee's head so that it was impossible to breathe. A cord was then tied around the neck, and the head immersed in water for three minutes at a time in order to obtain information. Detainees were forced to kneel on a bamboo pole while a second pole was placed behind the folded knees. A third pole was placed behind their back and their arms pulled over it. The torturer would then stand on the detainee's legs. An iron pole was rubbed up and down the shins of a detainee. Bullets were placed between the detainee's fingers and the fingertips drawn together using handcuffs. Three sharp stones were placed under each knee of a kneeling detainee who was forced to remain in the same position for two or three hours [Up-turned bottle tops are used in this form of torture against detainees in the Karenni]. Sometimes detainees were made to believe that they had been befriended by their torturer and allowed to smoke. Once they inhaled they were told they couldn't make smoke. When they eventually did, they were beaten." After six and a half years as an M.P., Bi Ya heard of the mass relocation of the Kayaw people in the Karenni. He deserted, and eventually joined his two brothers and half-brother in the Karenni Army.

Anticipating detention by the Burmese authorities, a Karenni underground operative narrowly escaped arrest in Loikaw, capital of the Karenni, and fled furtively to Thailand. The seventy-year-old-man had once fought the Japanese as a teenage irregular in the British Army. He believed he would die in jail if detained. "The situation now is worse than the Japanese time. In Loikaw, the conditions are very bad for the people; the value of the currency has depreciated and there's a scarcity of food. The people have to work hard to feed themselves, pay porter taxes, work on the construction of the railway line and roads, and provide security [for infrastructure and Burmese Army installations]. If we want to visit anywhere, even our farms, we need to get a permit. They are afraid to support the Karenni resistance. Everyone wants democracy and freedom but the military resorts to torture and

atrocities. They're now trying ethnic cleansing."

With inaccessible mountain ranges rising from mighty rivers and shrouded in dense forest, the Karenni is ideal guerrilla warfare terrain. Unable to defeat the Karenni Army by conventional military means, Rangoon declared war on the people in late May '96. 'Uprooting the Region' was the dictatorship's masterplan aimed at the outright annihilation of Karenni identity and the independence movement. Remote communities were relocated into internment camps or along main roads, which the authorities controlled. In urban areas, any attack mounted by the Karenni forces led to the townspeople being regarded as collaborators, and punished as retribution. (The Burmese Army had relocated Karenni civilians before; in 1976, 61 villages were forced to relocate to Mawchi town, while in 1992, 20,000 predominately Catholic villagers were forced to move to confinement camps in Pruso and De Maw Soe towns. However, the '96 relocation programme affected the entire Karenni population and at least nine relocation camps have been established by the authorities.)

On June 1st, 1996, the headman of Daw Taw Leh village (not its real name) received a written order from the township authorities on behalf of the army. It stated that his village "must move to and settle in Shadaw Town no later than 7-6-96 and those found in their village [after that date] will be categorised as rebels and shot". The headman called a meeting of the village elders. Having experienced brutality at the hands of the Burmese military on several occasions previously, they decided to flee to Thailand. The monsoon had just broken. Some of the elderly remained behind. Karenni guerrillas carefully shepherded the terrified villagers through areas crawling with Rangoon's troops. Exhaustion, hunger and malaria soon began to take their toll as they made slow progress eastwards. One by one, they were stealthily paddled across the raging Salween River in unstable canoes. Within days of arriving in Thailand, news reached the villagers that their cattle had been slaughtered

and their village torched.

Initially, ninety-six villages situated between the Pon and Salween were forcibly evicted. "They said if we didn't move they would cut our throats and burn our village. At first we fled to the forest, but they found us hiding." The miserable journey to Shadaw took several days for most and they were unable to carry much rice. Some villagers brought their livestock but the soldiers soon appropriated it. Although the authorities did provide some rice to the first arrivals, the provisions were soon exhausted. Shelter for the hundreds of downtrodden families arriving at Shadaw was non-existent. Some found temporary cover from the monsoon rains beneath the town's stilted houses or in an old school building, but many more slept on the cold ground. A new village was established on the slopes of a hill beneath an army camp. As well as constructing their own shelters, the detainees had to "cut wooden posts and bamboo to make a fence around the relocation site because the authorities were worried that the people would run away". Villagers were forced to repair roads and dig trenches for the military. They were not paid for their labour. Inability to work resulted in fines. Sanitation in the camps was also non-existent. "There was no toilet in the camp, so we went to the toilet anywhere, [and] caught many diseases." The sick went to the hospital where "they were given injections [but] they only used one needle for ten people. The villagers had to drink water from a ditch which had sewage in it and 120 died in one week." Wells were sunk, but the authorities, apparently fearing an epidemic, "put pesticide into the wells without any prior warning; five adults and ten children died." The authorities repeated this in August '97, but this time it was regarded as a deliberate poisoning, resulting in over fifty deaths. The fear of hunger and death drove many condemned villagers to escape to survive. Creeping past sentries at night, the fugitives initially made for home. "While we were hiding we saw SLORC soldiers come to our village and torch it". "There was on old lady called Pi Mo who had stayed behind because she was too sick to go anywhere. They burned her house with her inside. She died in the fire." Another elderly woman was stabbed to death. The Burmese Army was systematically looting and burning all villages, destroying farms, rice stores and paddy, while executing anyone they came across. Chickens, pigs and cattle were stolen, eaten, or killed. The area is now a free fire zone. Anyone and everyone is shot on sight. Tens of thousands of internal Karenni refugees are barely surviving on yams, roots and edible leaves, fearful of random execution. Not so long ago, these remote hill farmers co-existed peacefully with their environment and had never set eyes on a Burmese soldier. They now dread the day that happens.

'Uprooting the region' has been so incisive in applying pressure on the Karenni that the junta has expanded the programme to include two thirds of the state's territory. On March 13th, 1997, Burmese troops raided Show Kah village (not real name) in the expanded relocation area, not far from Mawchi town. They captured nine people, six of whom were children. Their hands were tied behind their backs. An elderly widow was the first to have her skull smashed with a huge wooden pestle, normally used for pounding rice. Four of her children watched on in sheer horror. They, and two other children, had also been captured. All were battered to death in the same brutal way. Landmines were laid in the village to prevent the villagers, who had run away, from returning. One villager, who dared to return, stepped on a landmine and lost a leg. The authorities fined him. He had to pay for the mine.

Around four thousand Kayan relocation victims managed to reach Thailand, arriving with little more than the clothes on their backs. Most had never strayed from their villages before. They had never seen a motorcar or a television. Their villages had no electricity even though Lawpita hydroelectric dam, which generates the majority of Burma's power, is located nearby in the Karenni. The new arrivals were more concerned with avoiding forced labour, and not having to porter for the Burmese Army. They were relieved to get reliable medical attention. Most arrivals needed it. Tuberculosis was a major concern. The children were quickly inoculated

against a variety of diseases. The medicine, and medical supervision, was provided by International Rescue Committee, funded by USAID. Once the schools were built and the teachers found, youngsters had the opportunity of attending school, the majority for the first time.

A process towards peace had once seemed possible when, in March '95, the Burmese Military dictatorship and the Karenni leadership declared they had 'come to terms' and a cessation of hostilities would follow. Thousands of excited exiles returned to Karenni designated areas from refugee camps in Thailand. The junta trumpeted its fifteenth cease-fire and provided finances for the development of the Karenni controlled area. Logging concessions were honoured by the Karenni Government, and tens of thousands of tonnes of sawn timber from trees felled years before, was sold surreptitiously through Thailand. Within three months, Burmese forces were mounting yet another massive operation aimed at annihilating the Karenni. For the first time ever, Burmese forces captured all major Karenni bases and thousands of bitterly disappointed refugees poured back over the frontier into Thailand to re-establish their former refugee camps. But the guerrilla war continues unabated and largely unreported. With no hope of winning the war militarily, it would be more accurate to say the Karenni continue to fight so they are seen not to lose the war.

And the war and human rights abuses continue, "On 26 August 1997 at 0830 hrs, one SLORC soldier of LIB 102 stepped on Karenni landmine near the cemetery of Kwa Kee village and one of his legs was blasted off. On the same day at 0930 hrs, the Karenni Army again attacked the SLORC troops near the cemetery. The SLORC troops suffered one wounded. On the day at 1100hrs, the Karenni Army attacked while the SLORC troops were burning the church of Kwa Kee village. 4 SLORC soldiers were wounded in the attack."

"On 2nd March 1998, SPDC troops led by Colonel Ngwe Soe from LIB No. 423 killed Saw Ba Moo Doh, 37 years old, from Sho Lo village, in the jungle after accusing him of having connections with the Karenni Army. On the same day, SPDC troops led by Lt. Maj. Win Hyway, second commander, from IB No. 102 shot dead Saw Be, 28 years old."

"On 4th March 1998, troops of SPDC led by Lt. Maj. Than Aung captured and raped Naw Kreh, 25 years old, from Sho Daw Kho who was on her way home, and finally stabbed to death."

"SPDC troops from LIB No. 423, 427 and IB No. 102 under the command of brigadier Thet Tun have been restarting their military operations with the policy of uprooting areas. Villagers from 24 villages that are located around Mawchi will be killed if they are seen in their old villages. So far, the SPDC troops have killed 6 villagers. Fighting between SPDC troops and the Karenni Army has been occurring almost everyday. To be continued . . ."

Dean Chapman

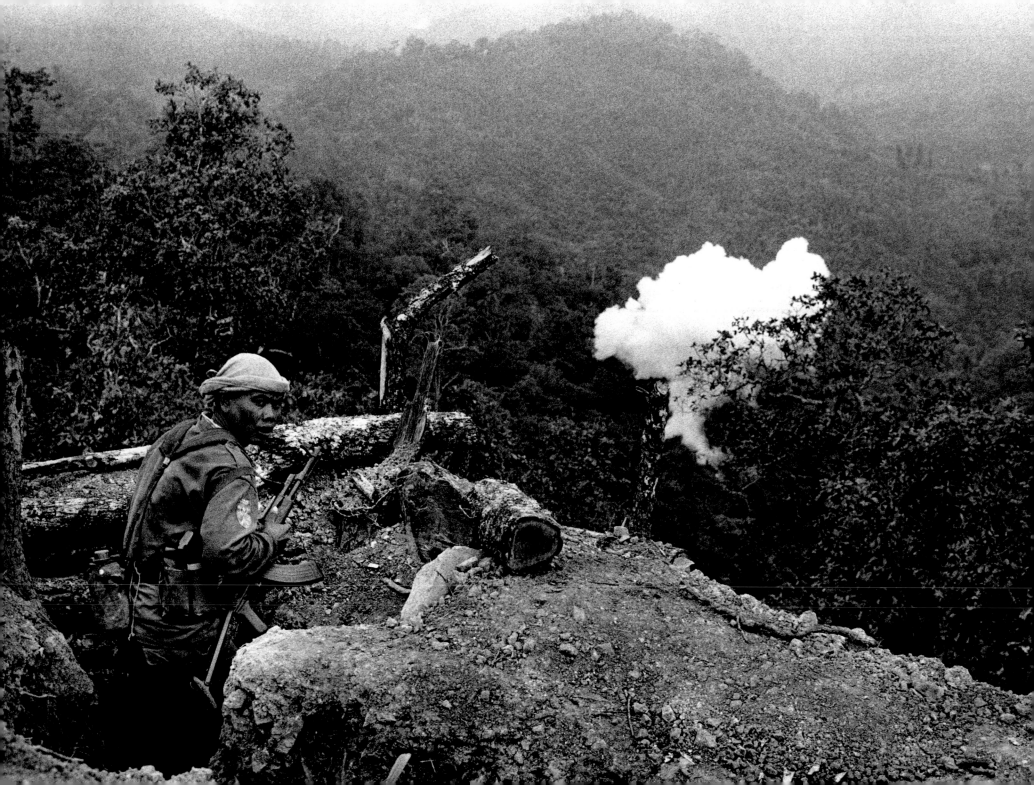

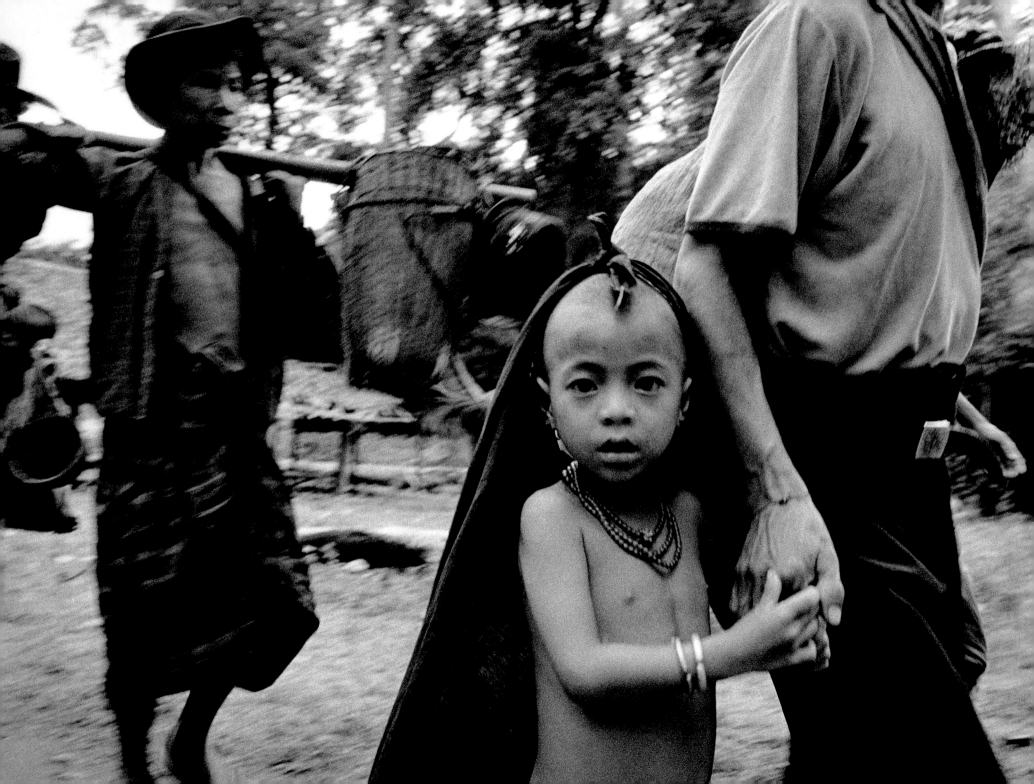

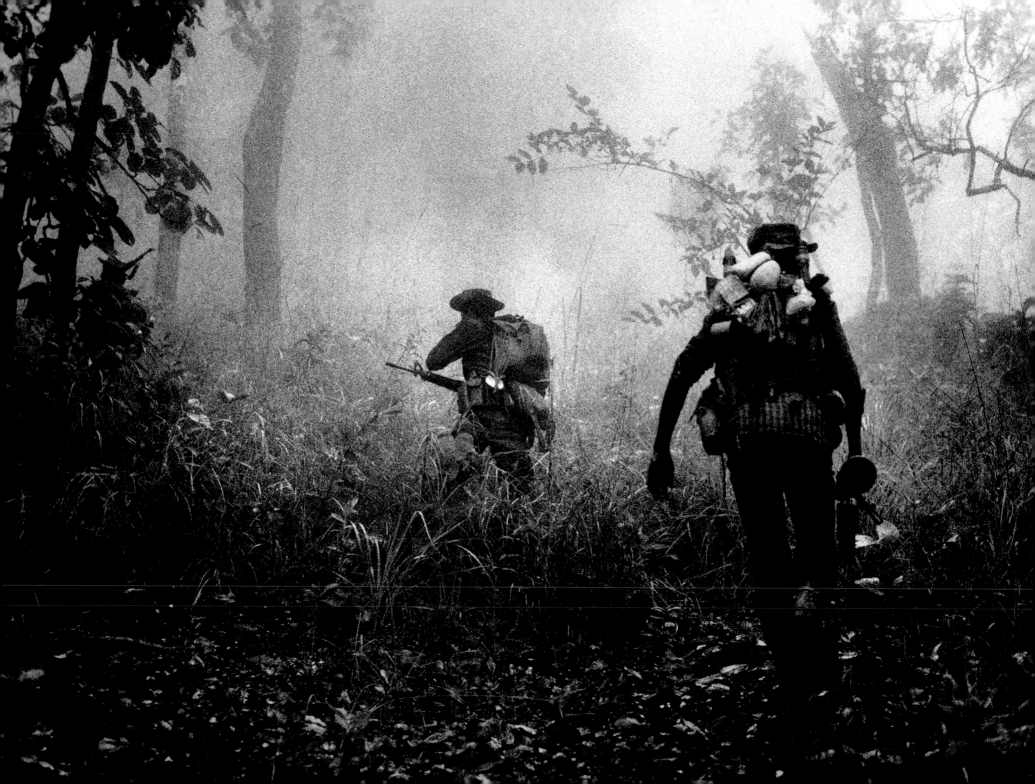

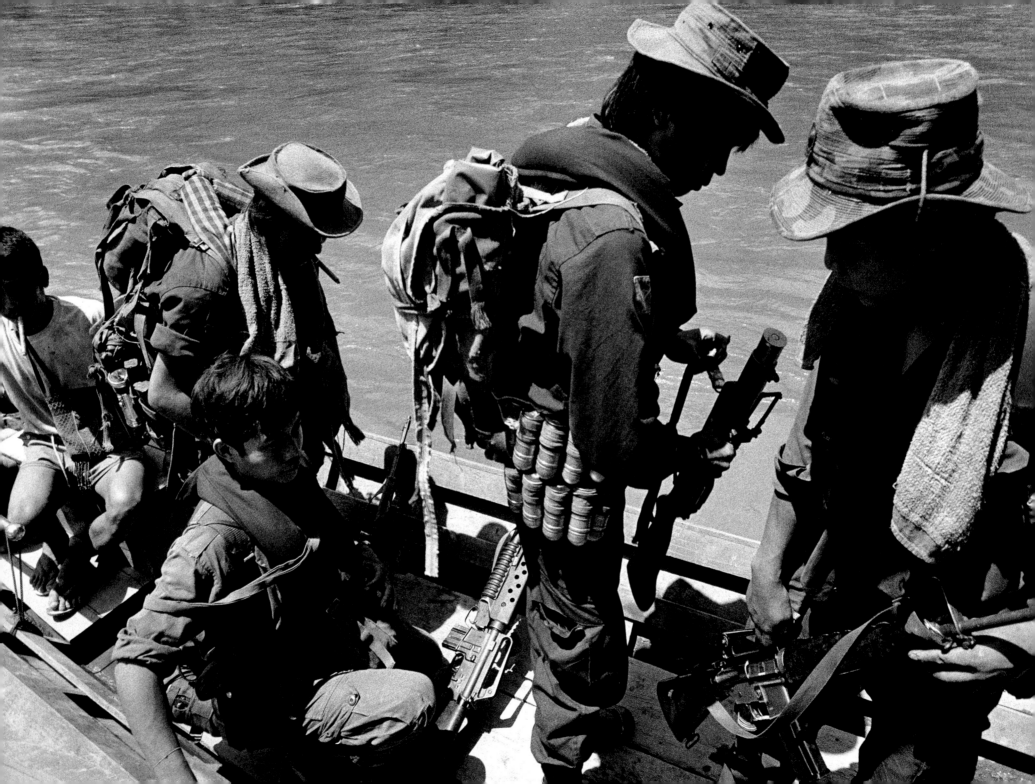

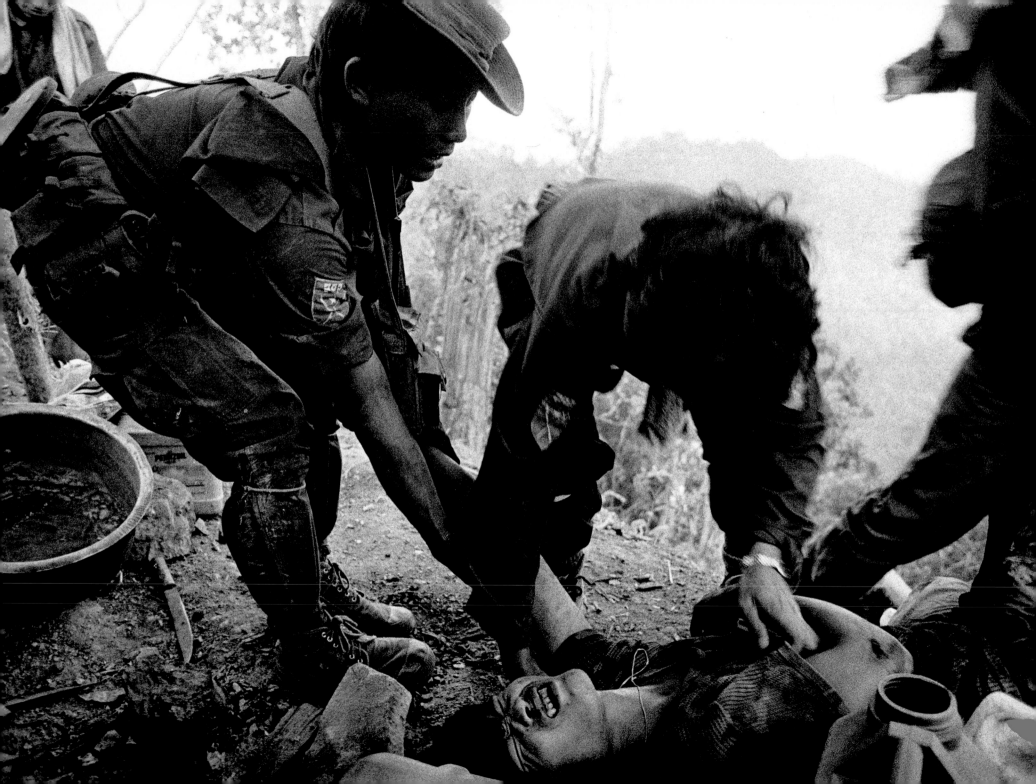

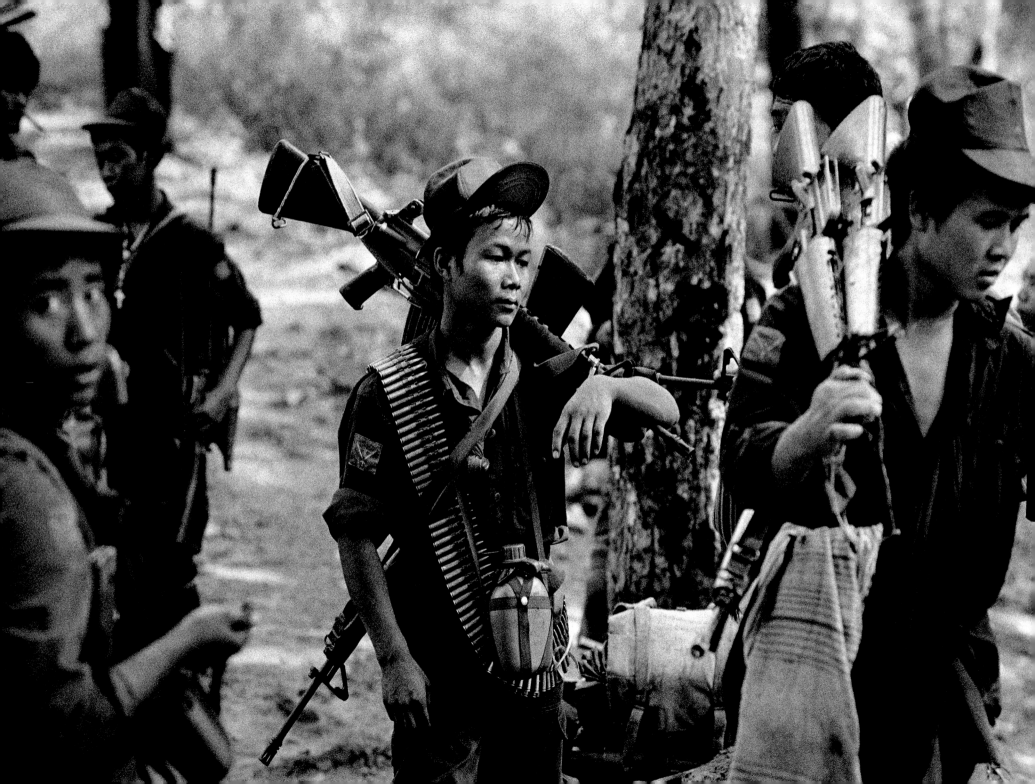

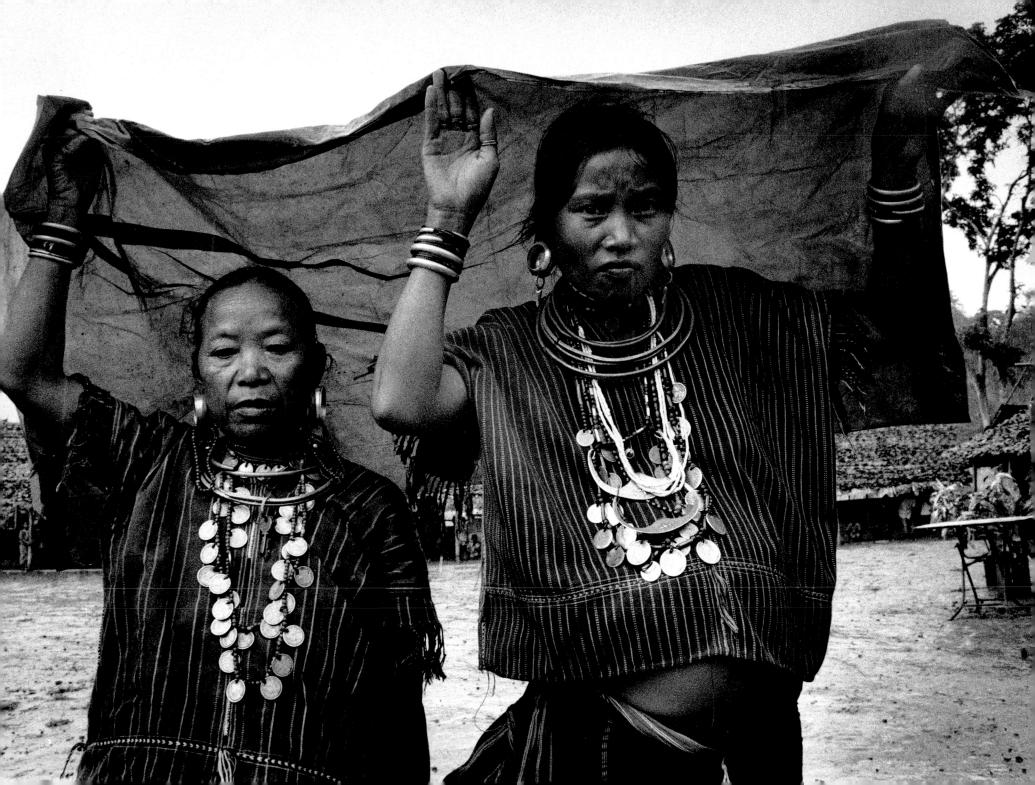

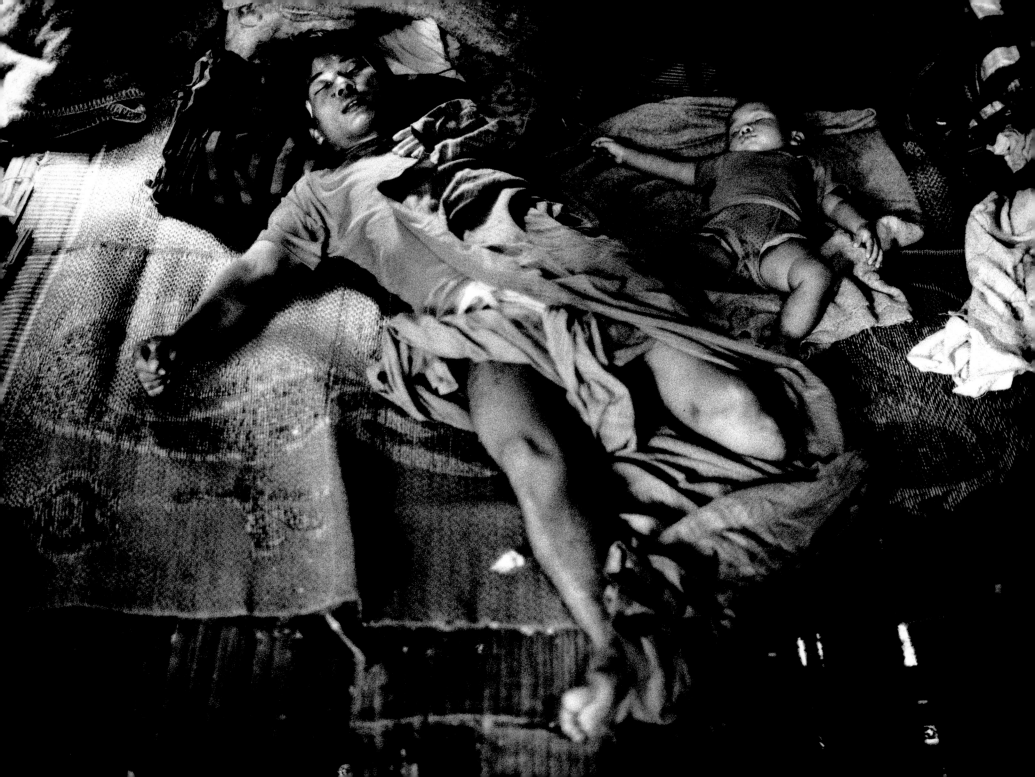

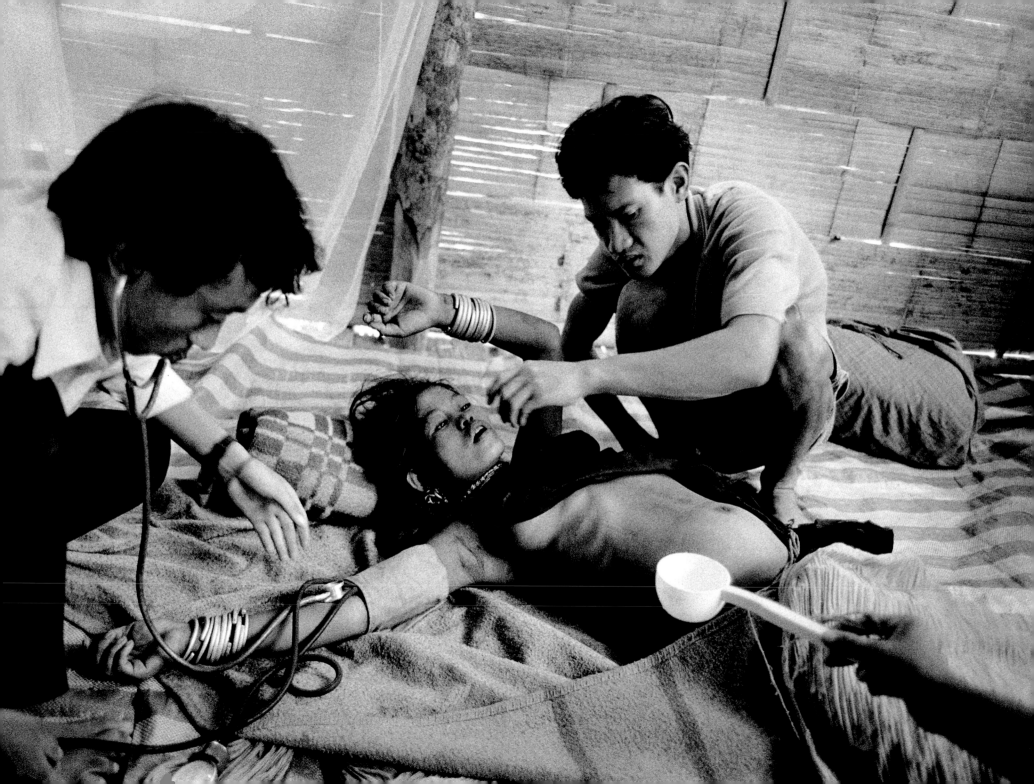

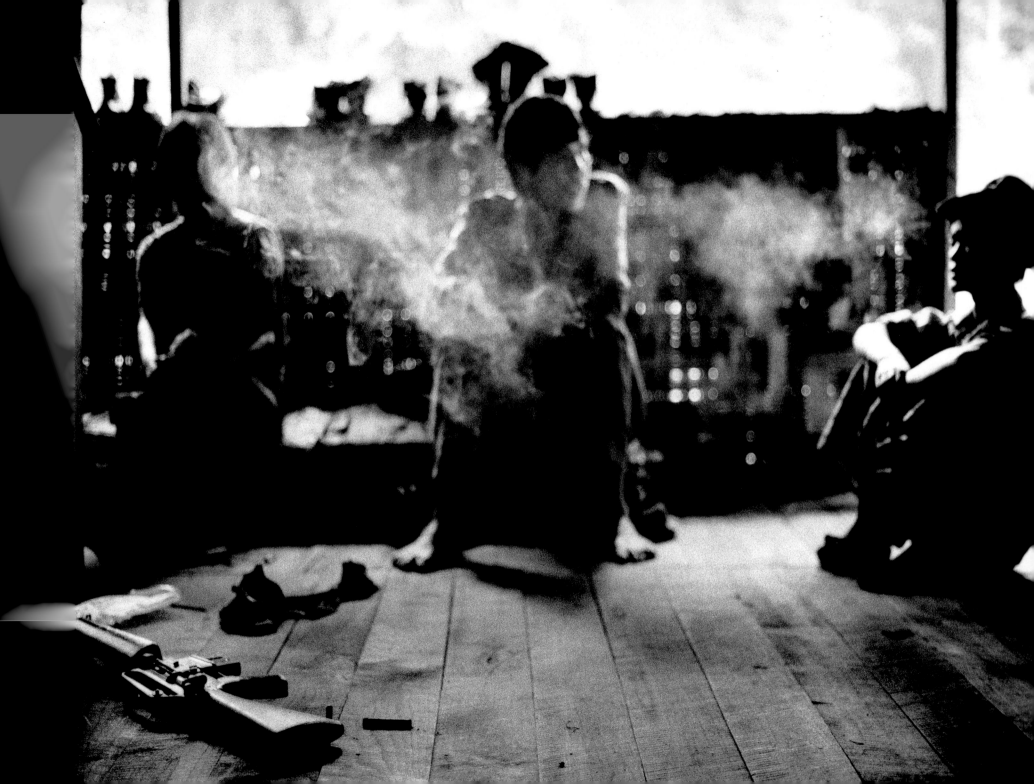

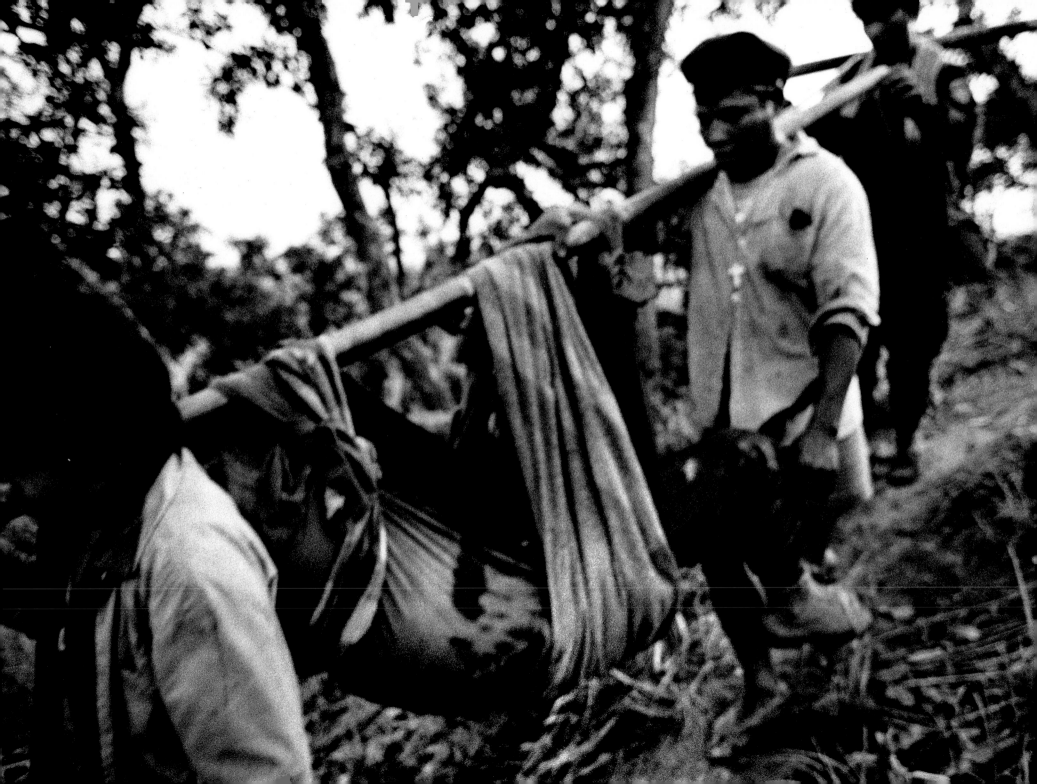

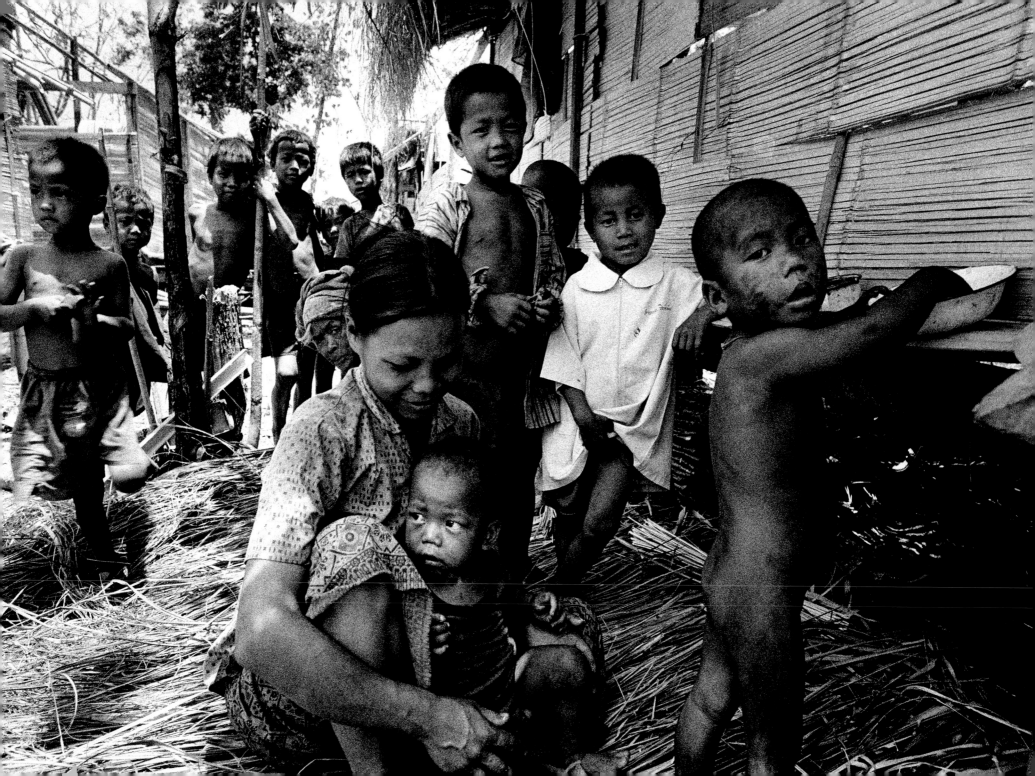

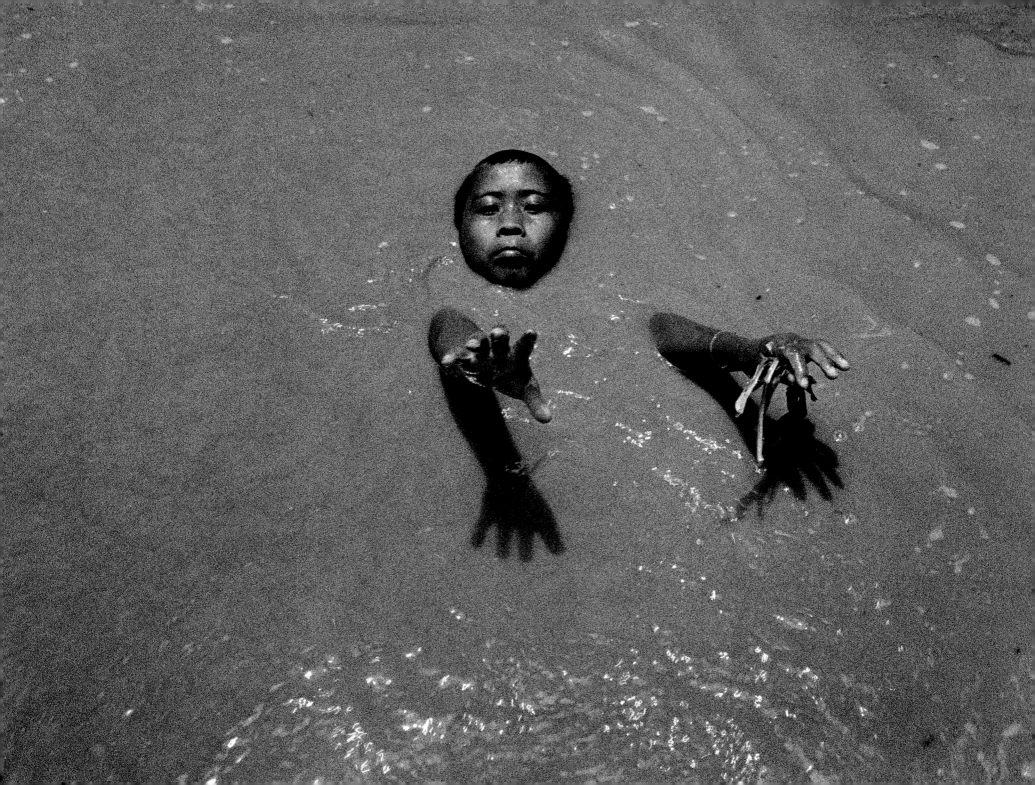

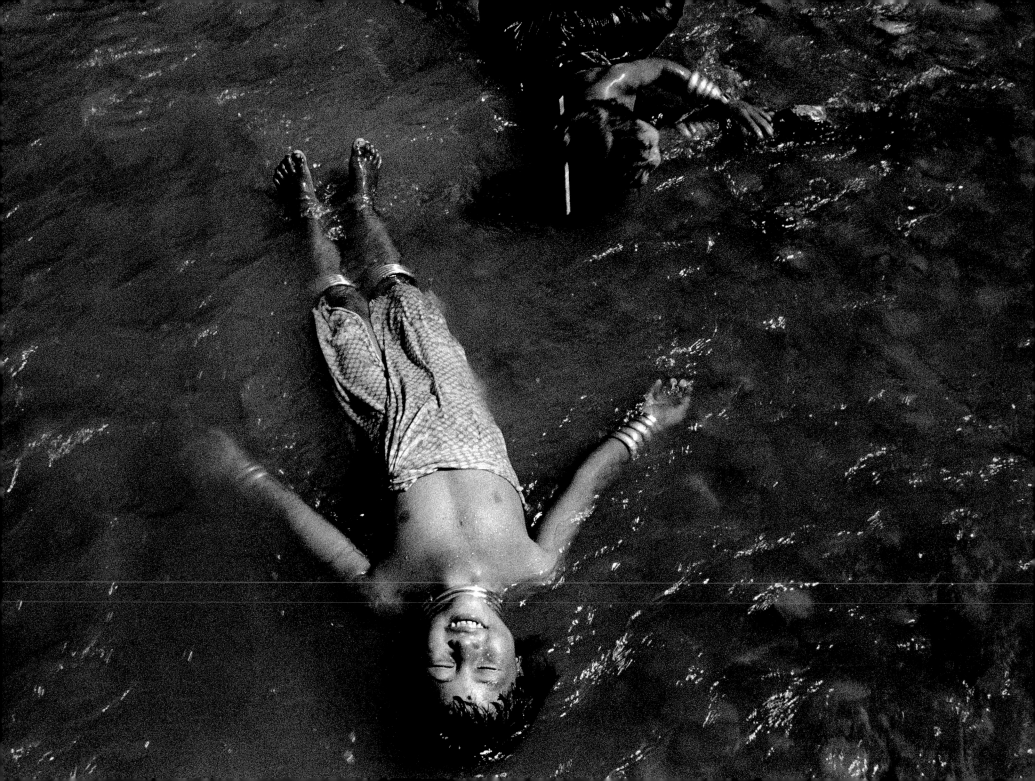

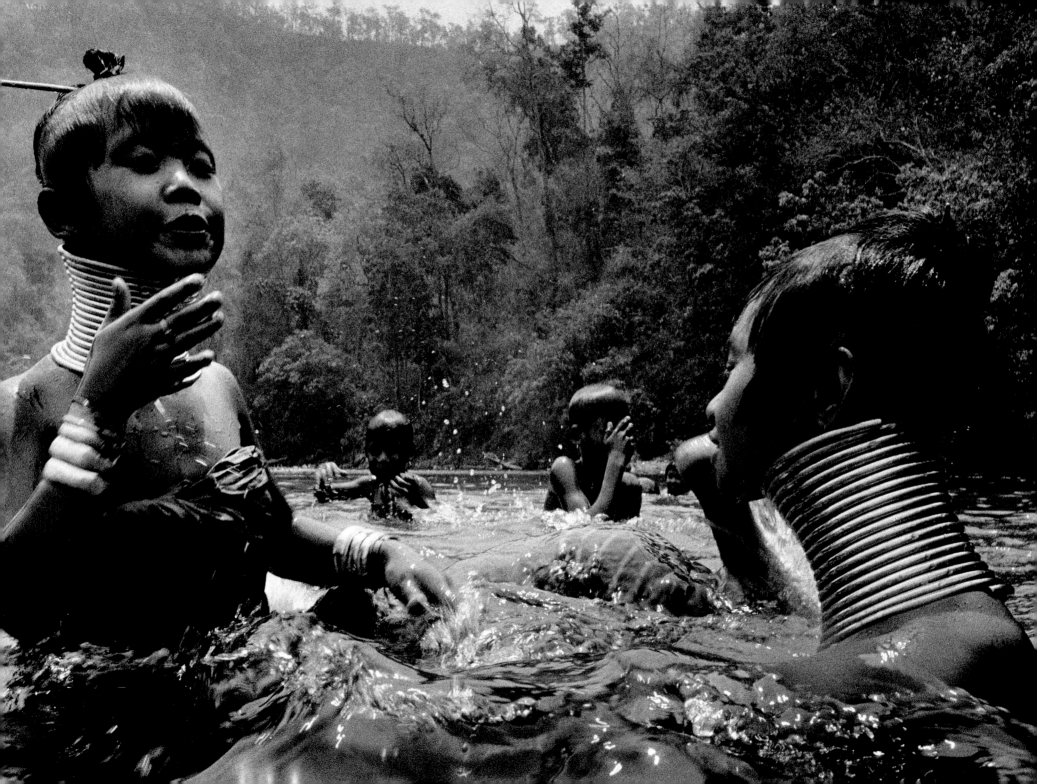

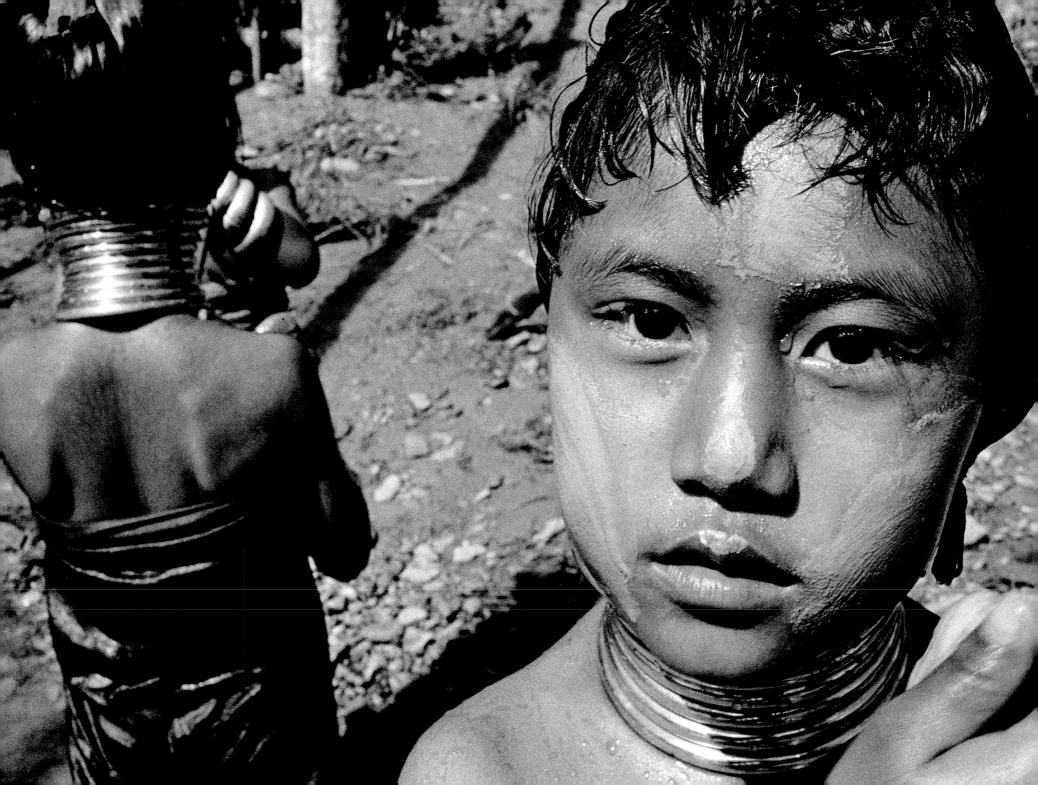

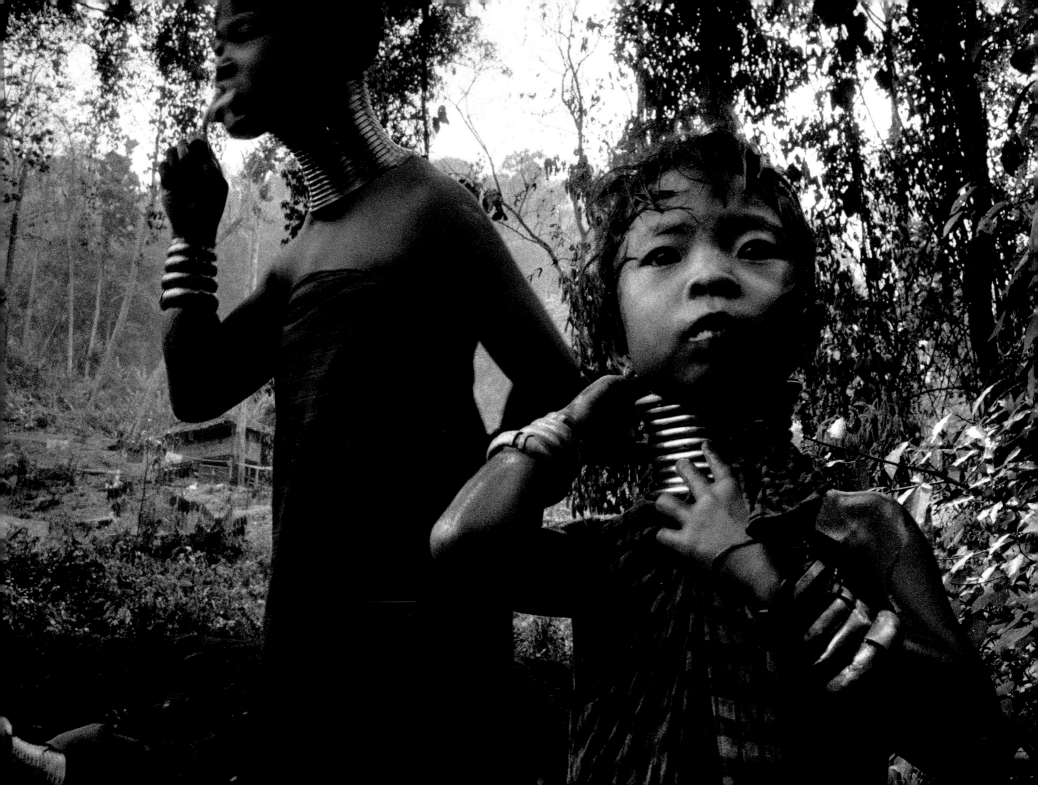

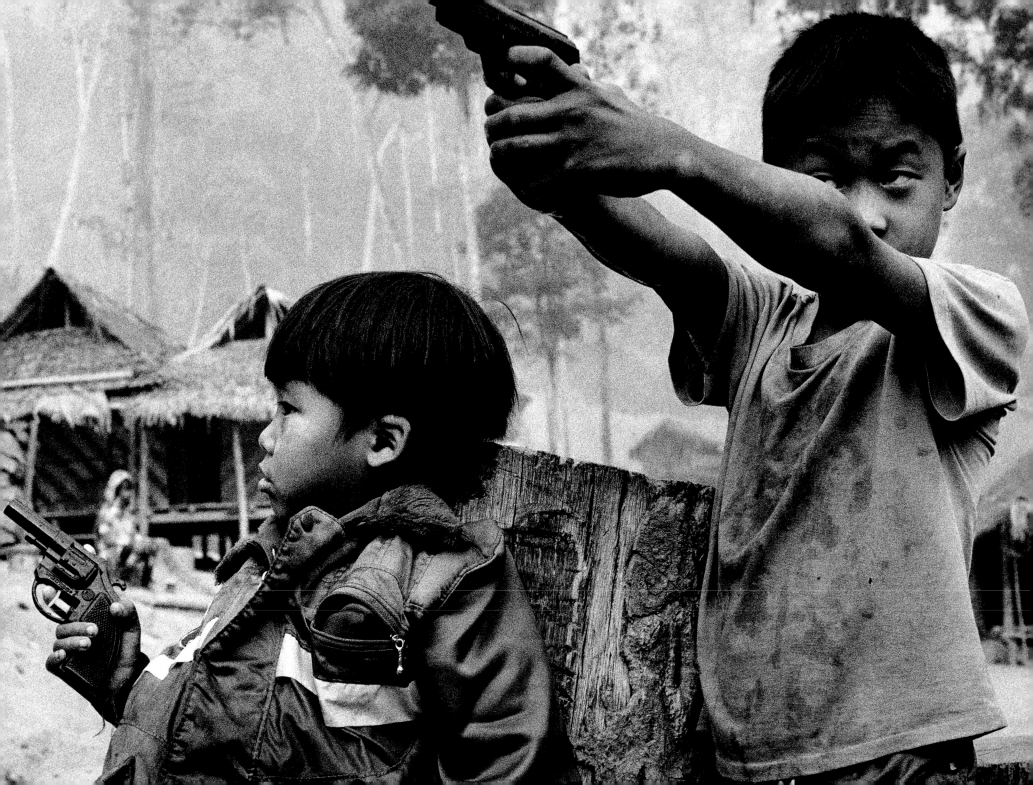

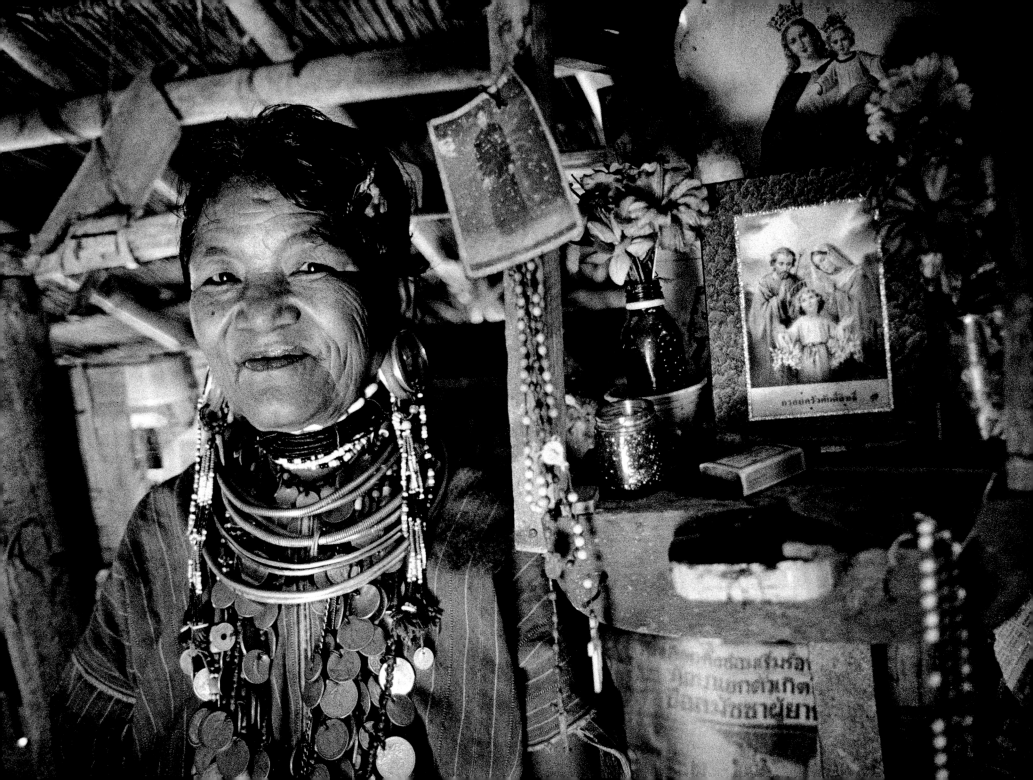

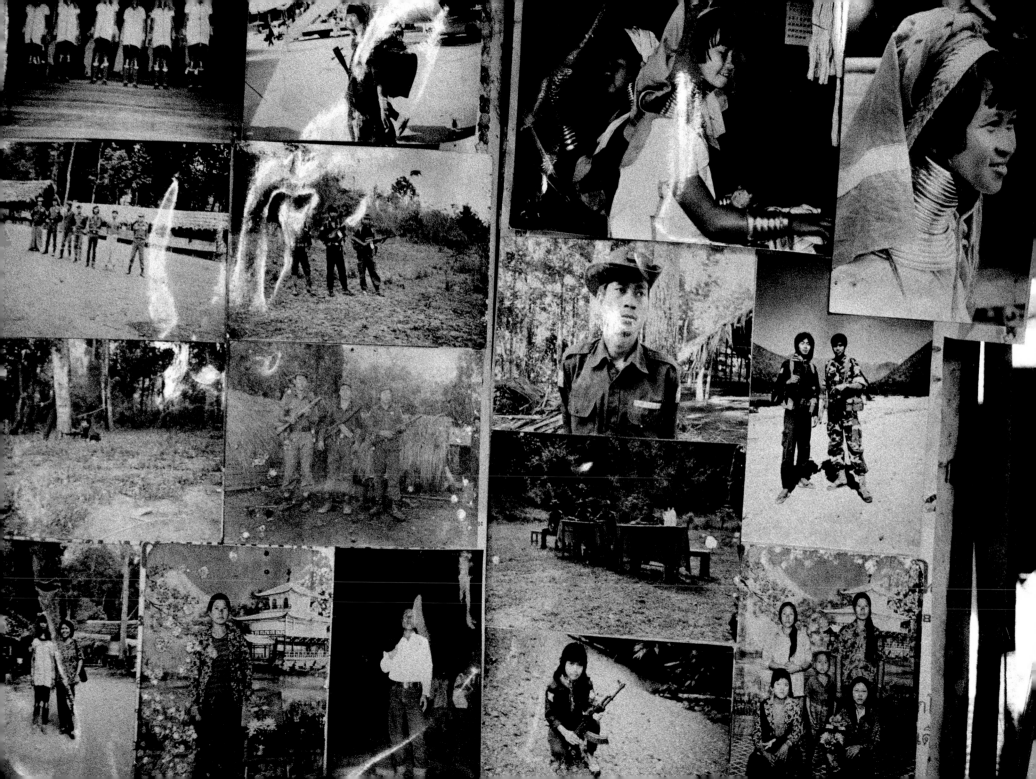

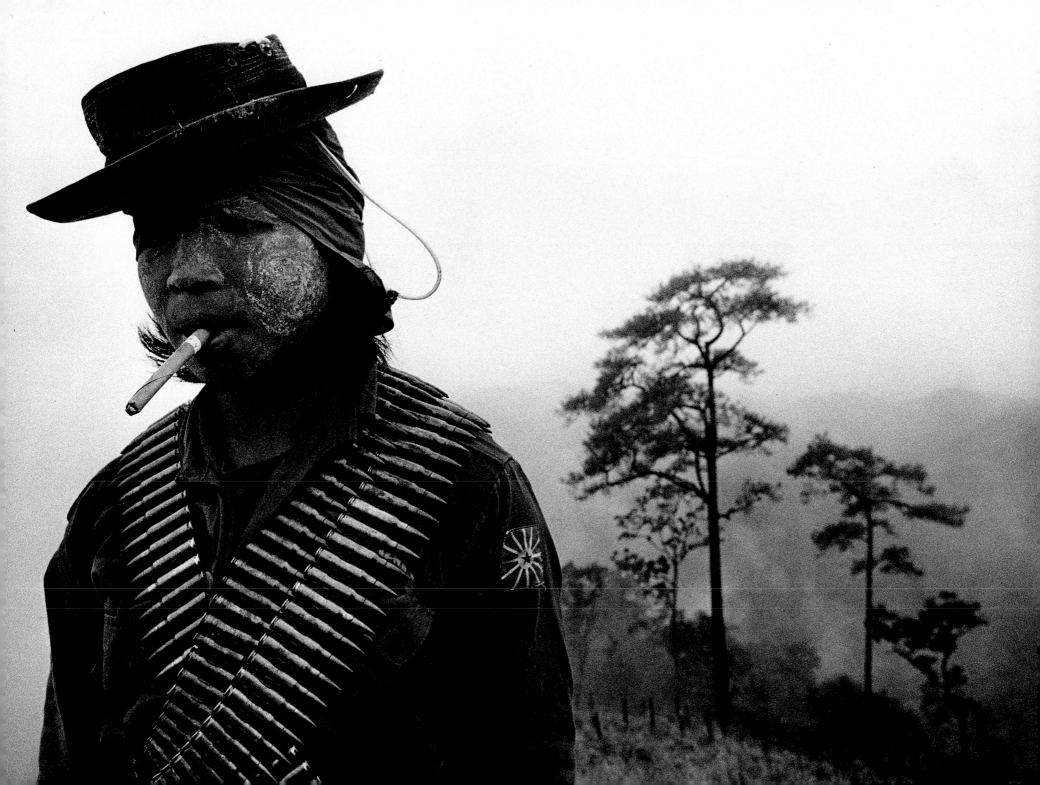

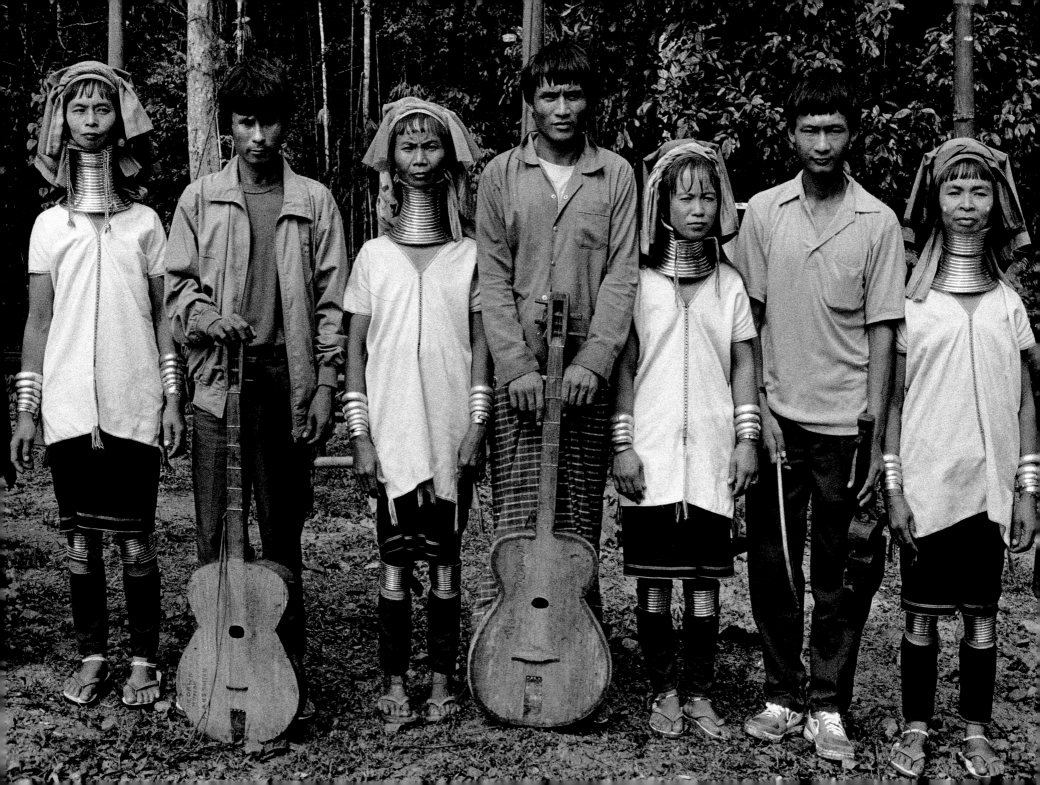

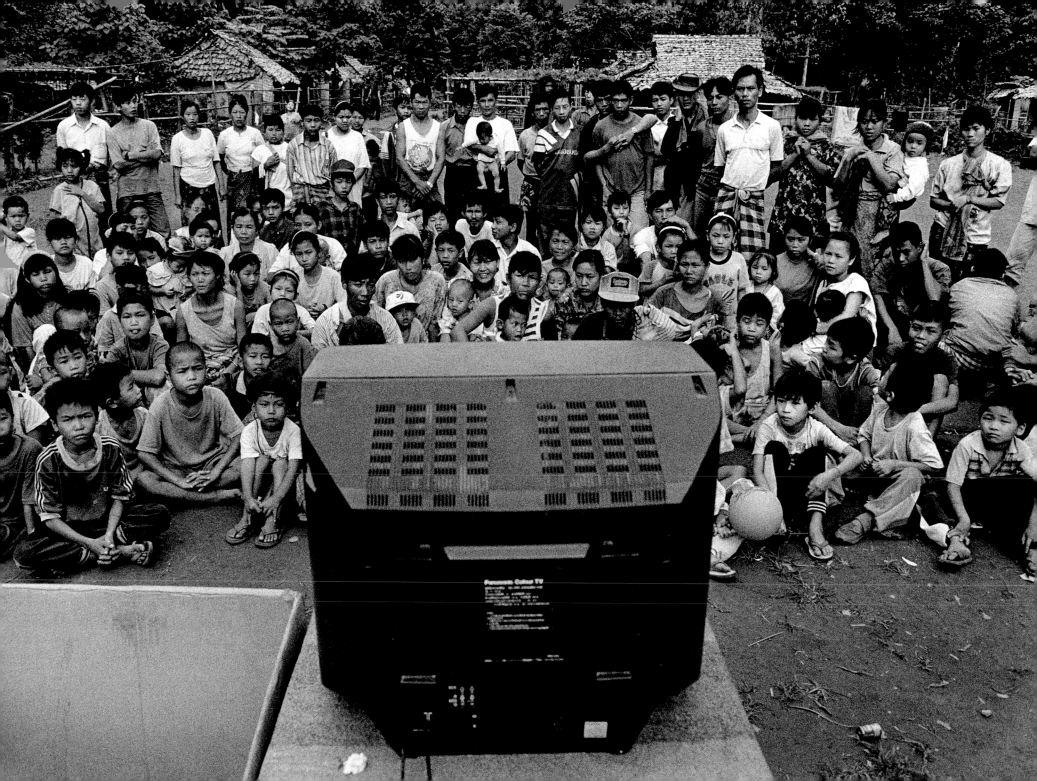

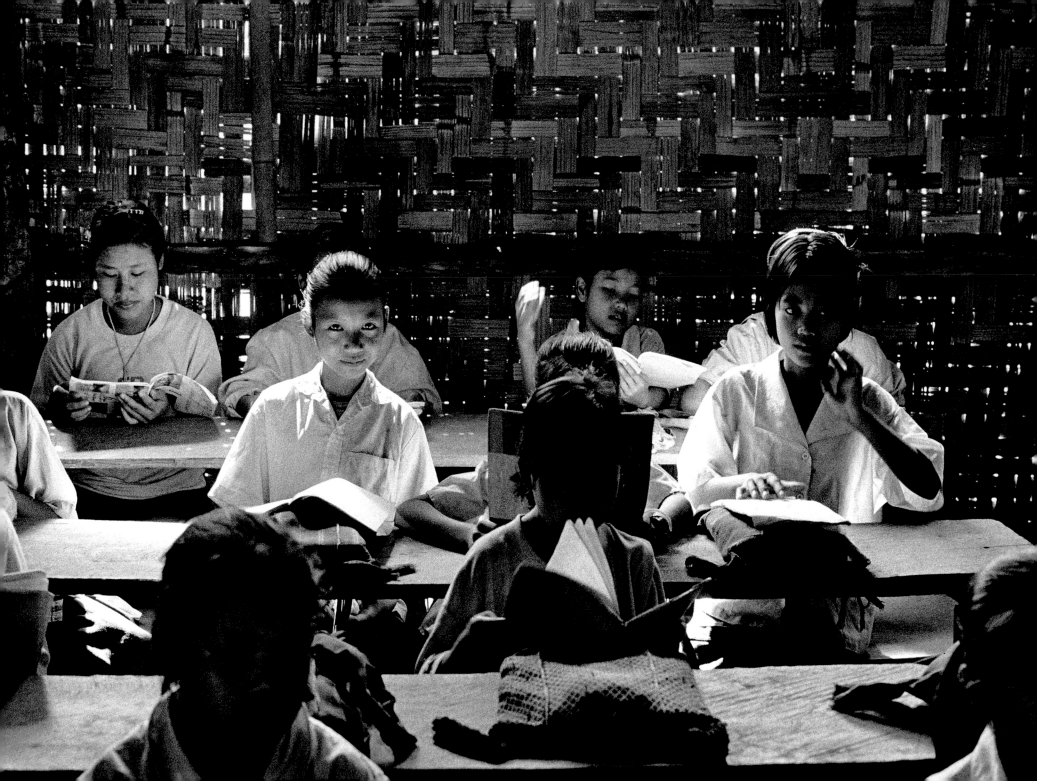

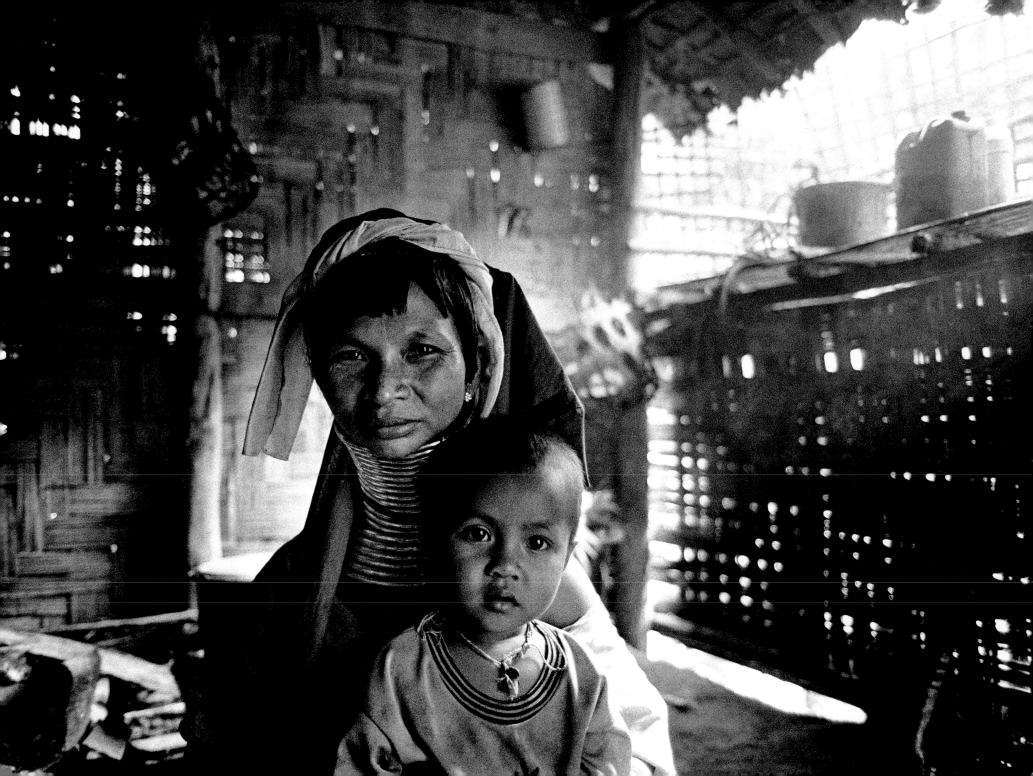

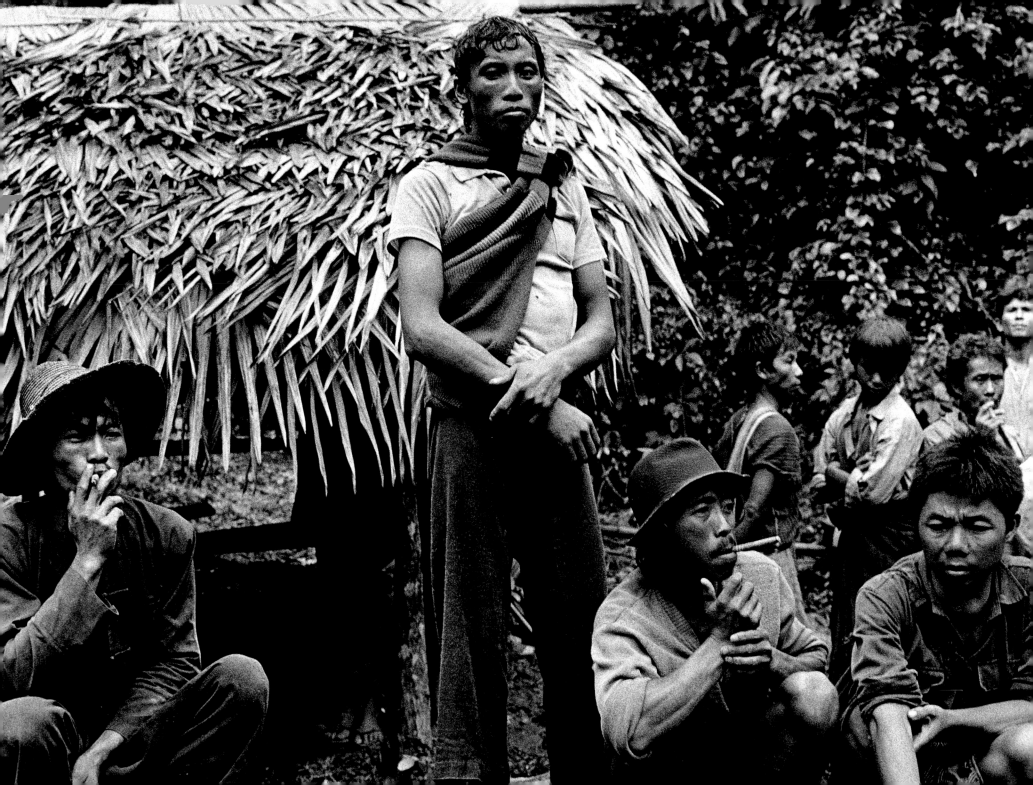

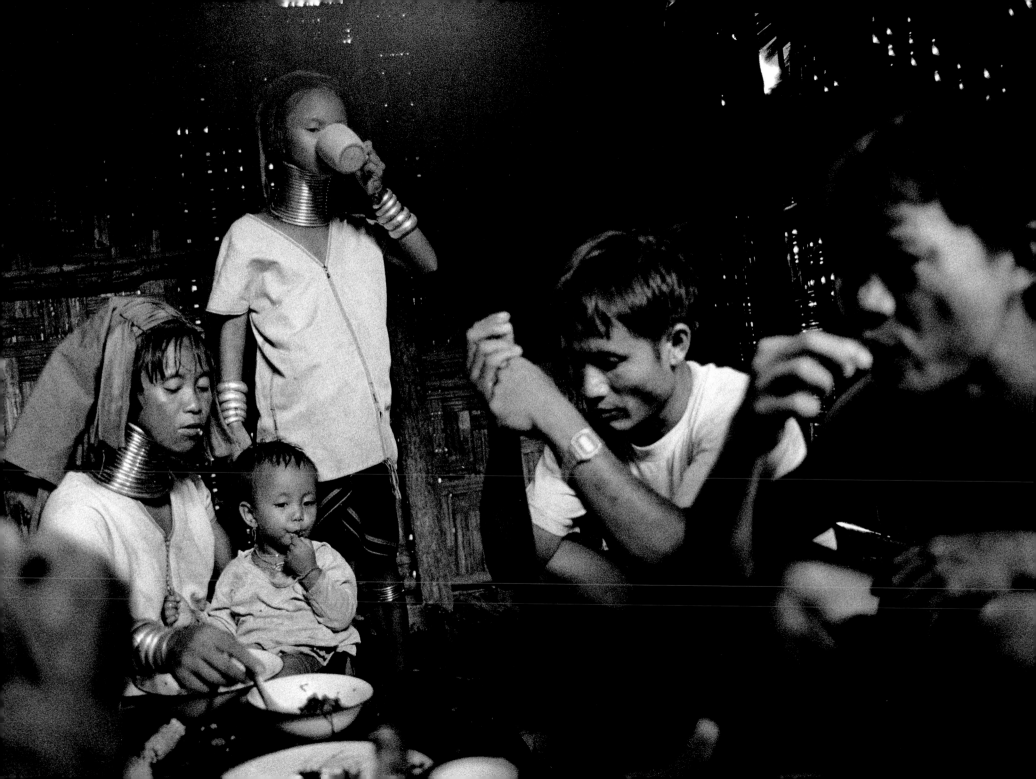

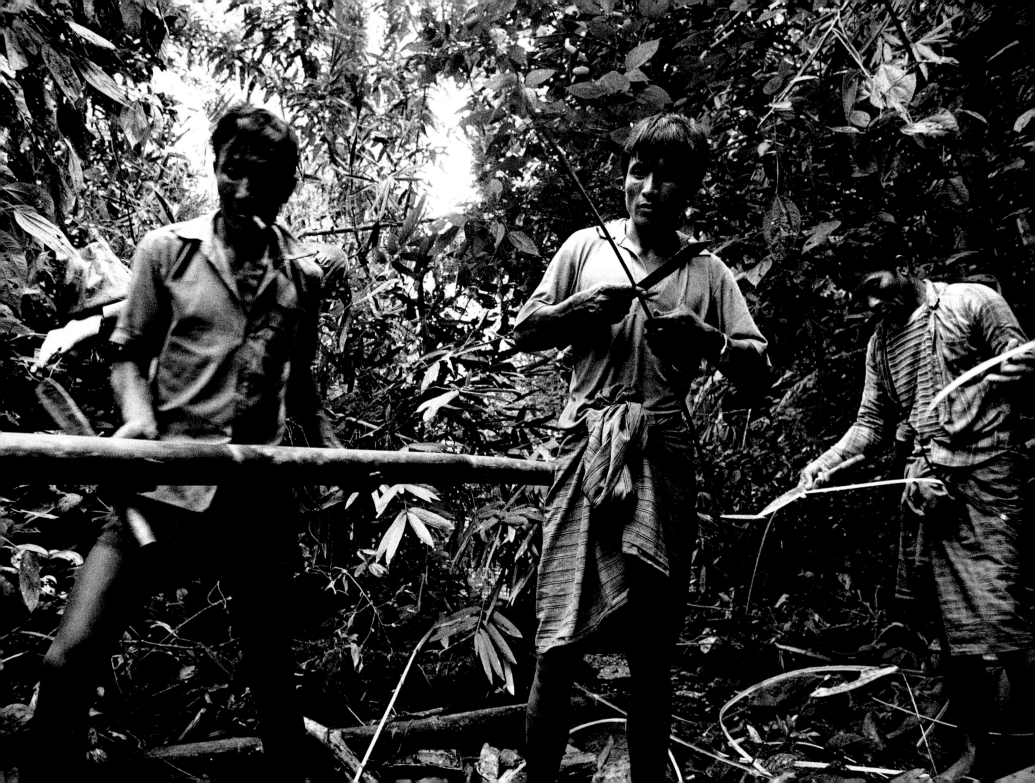

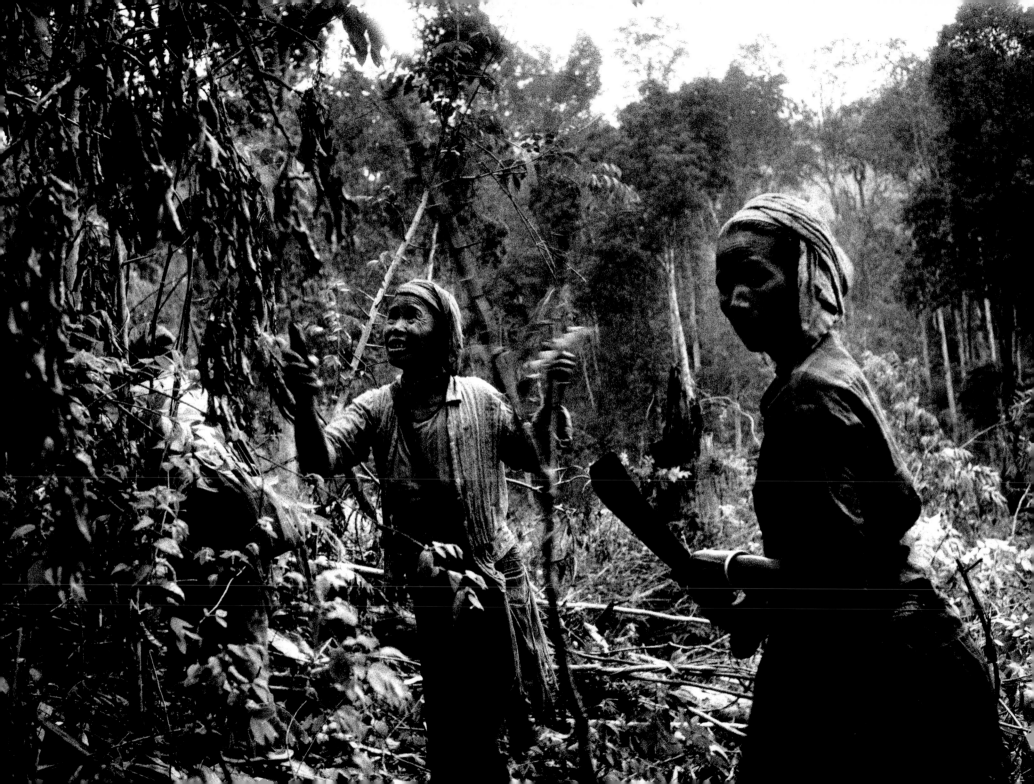

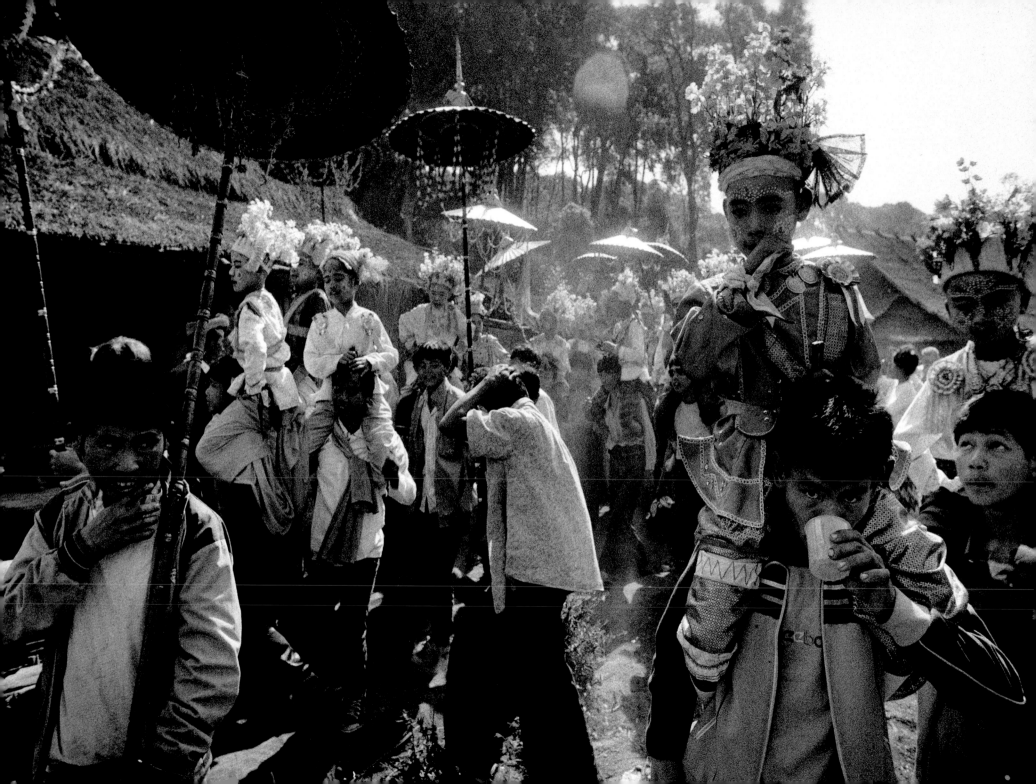

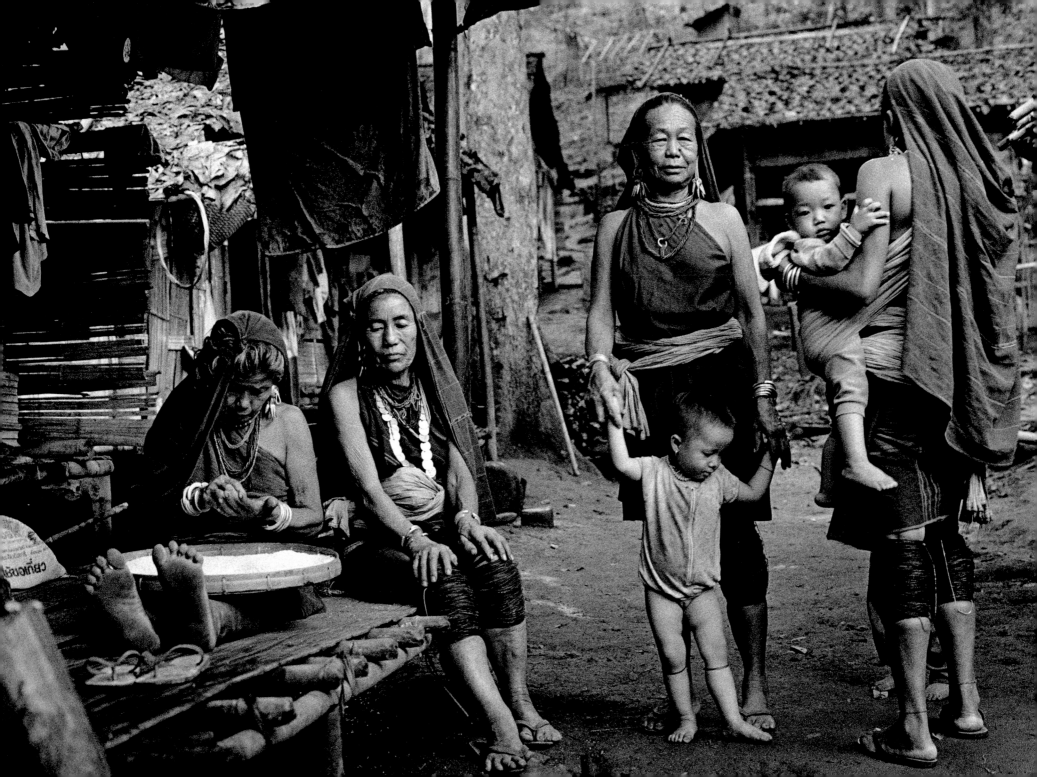

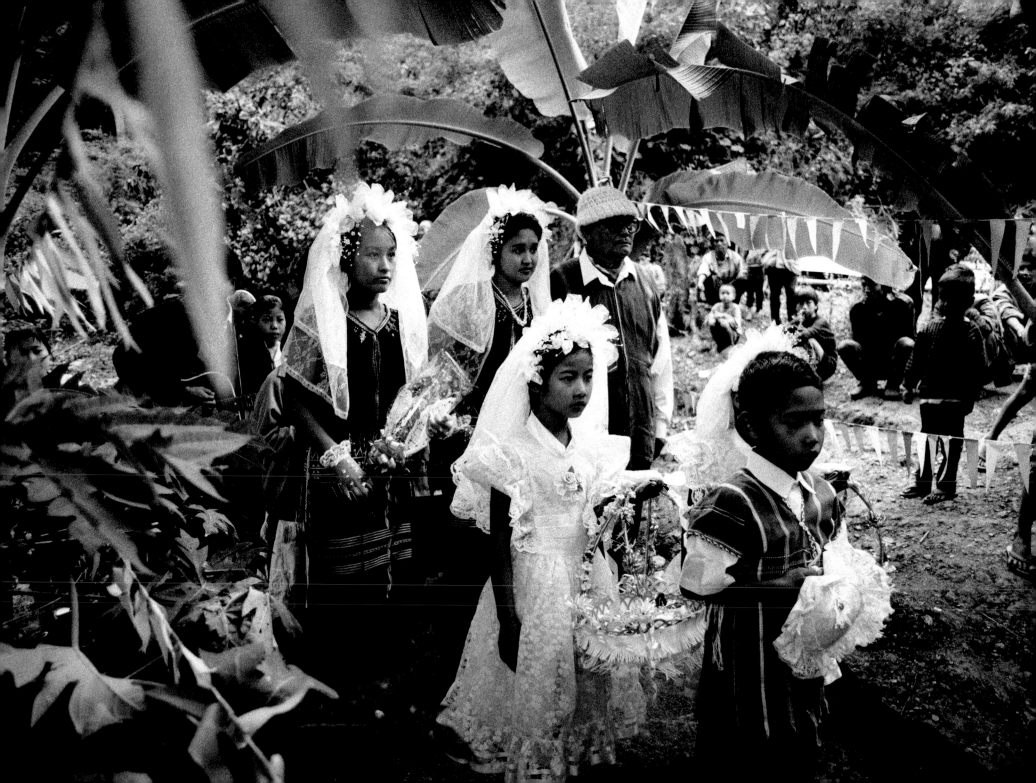

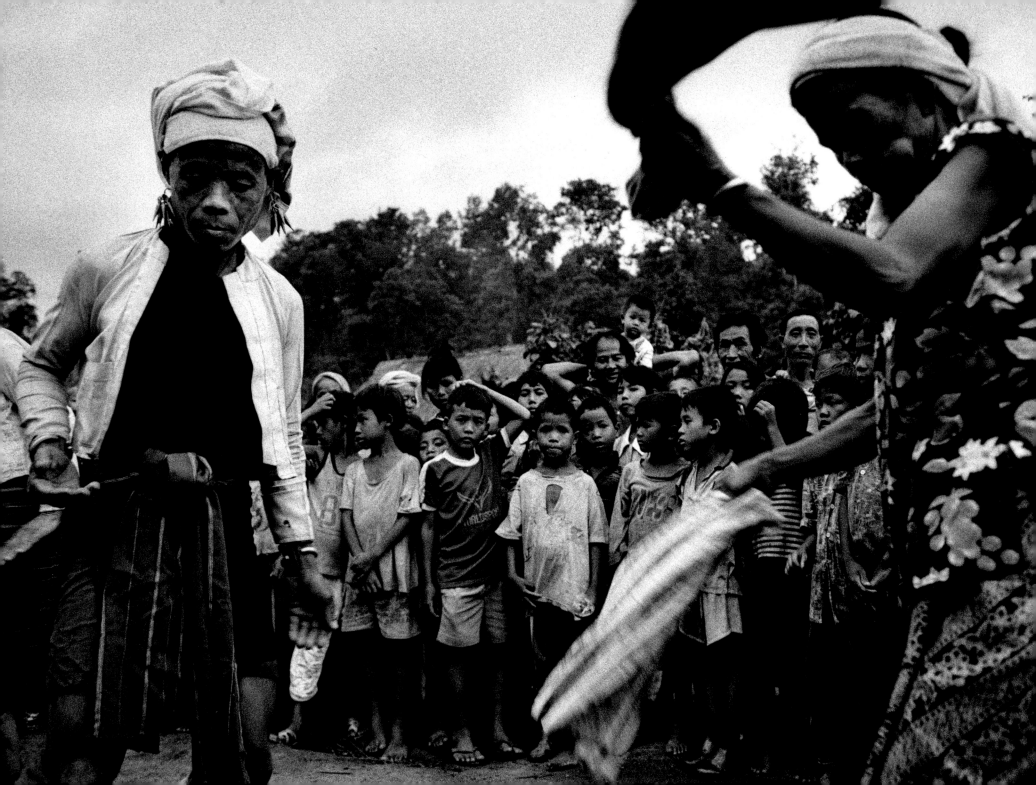

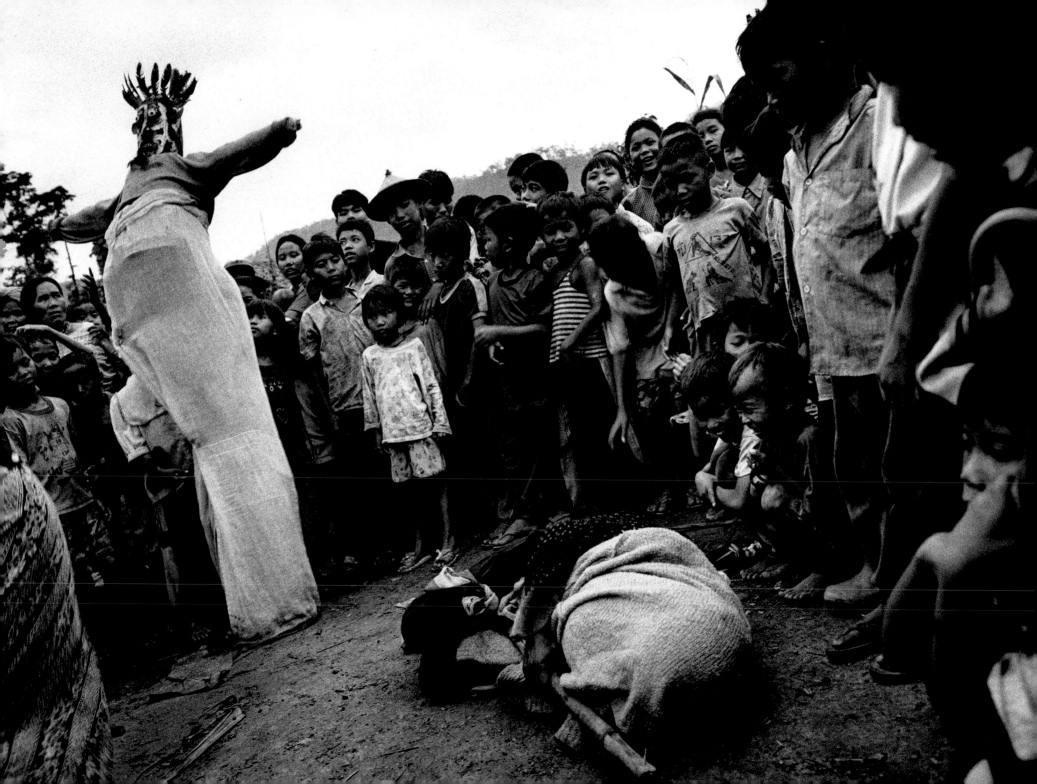

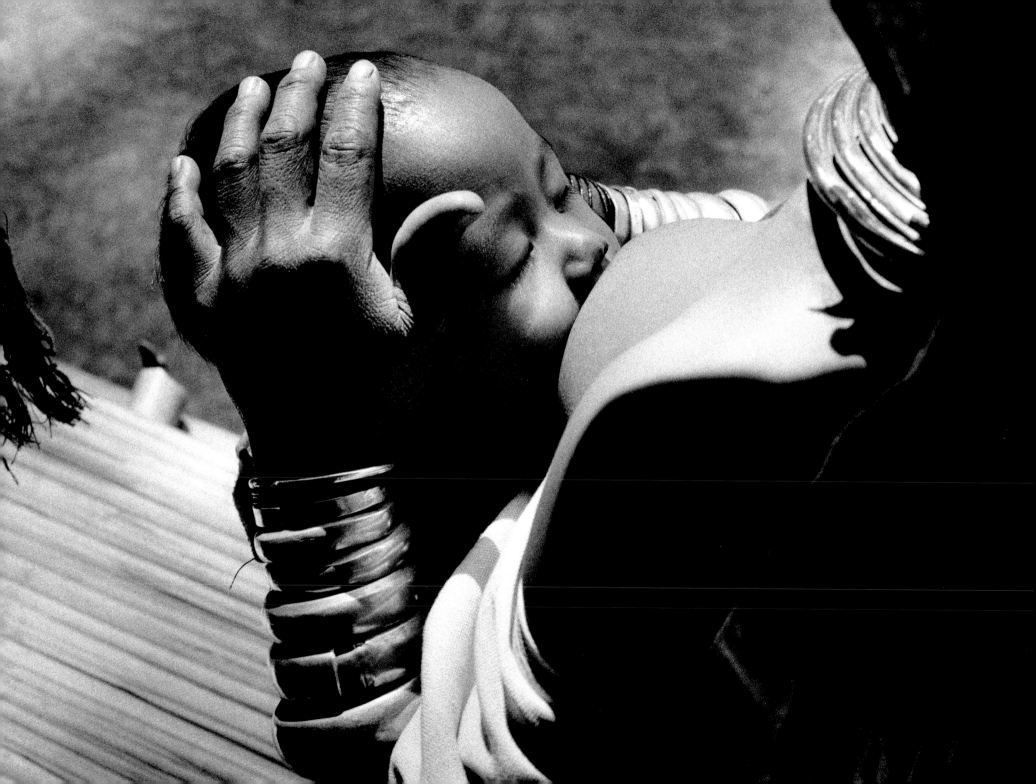

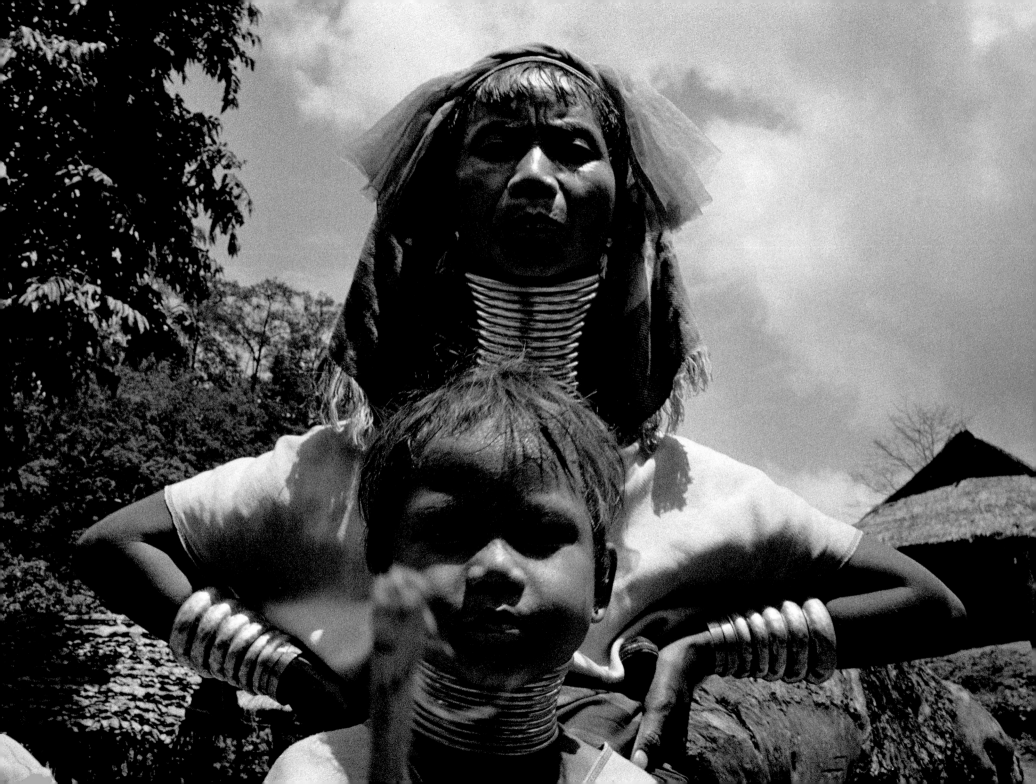

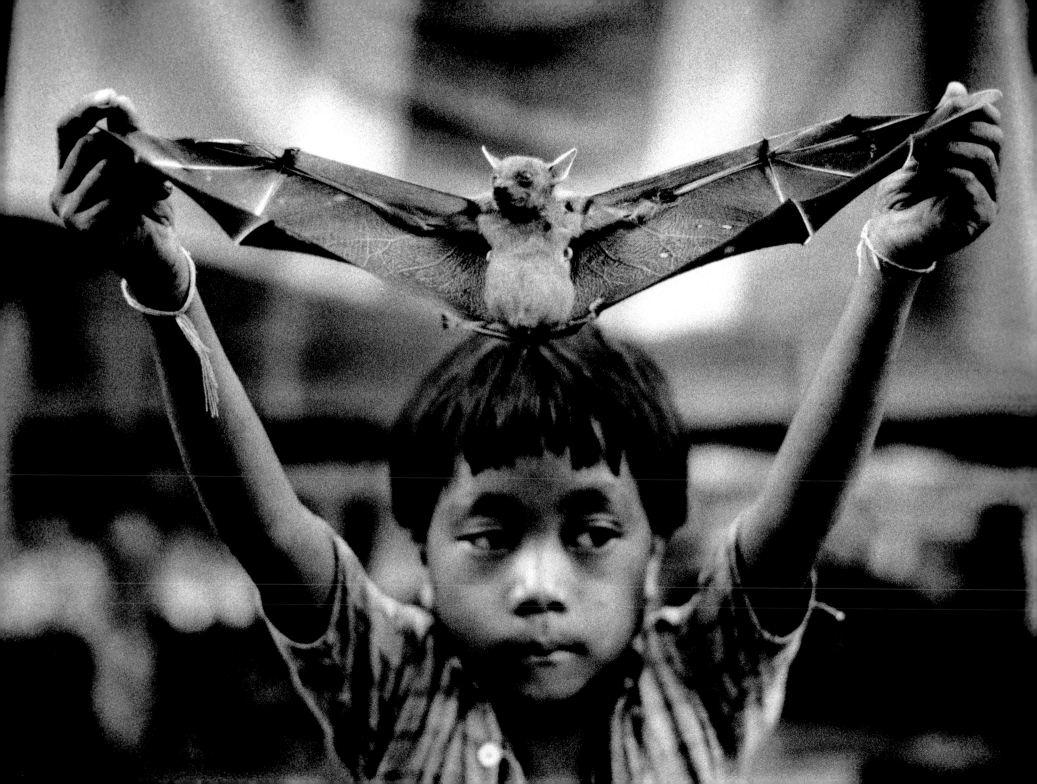

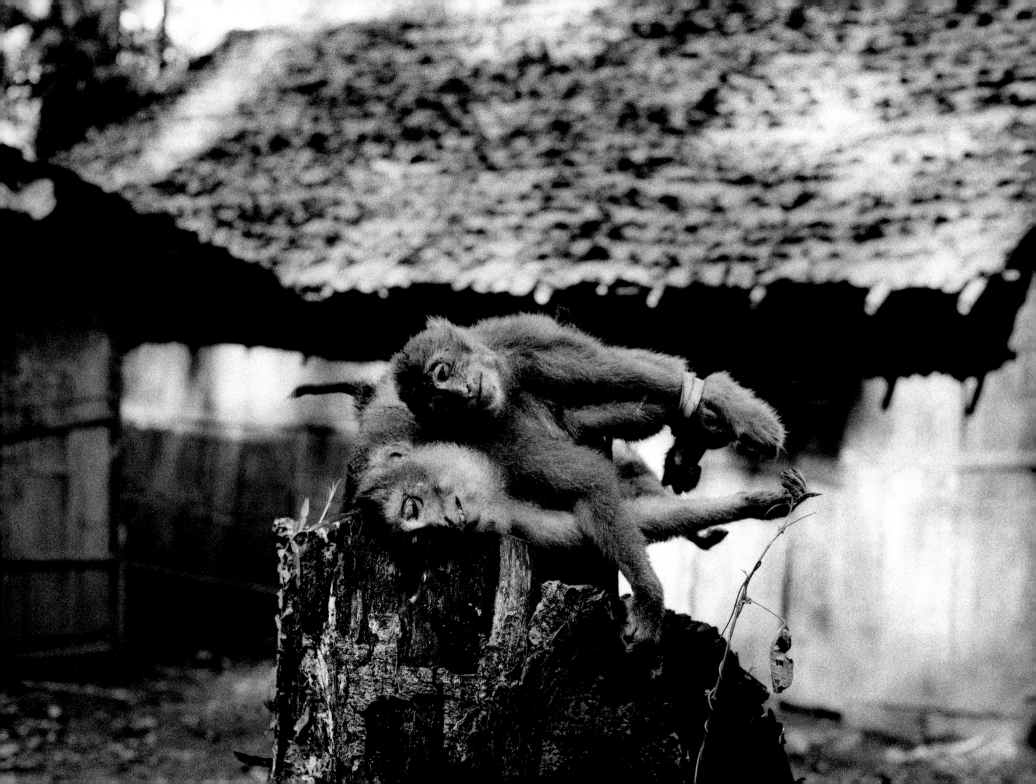

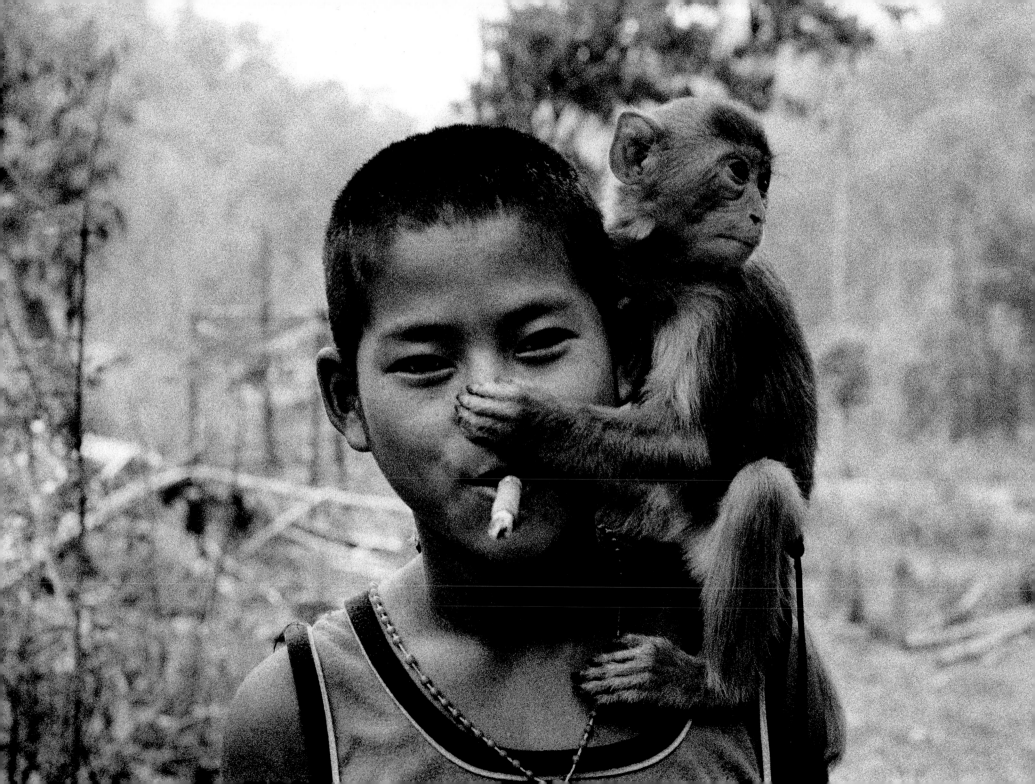

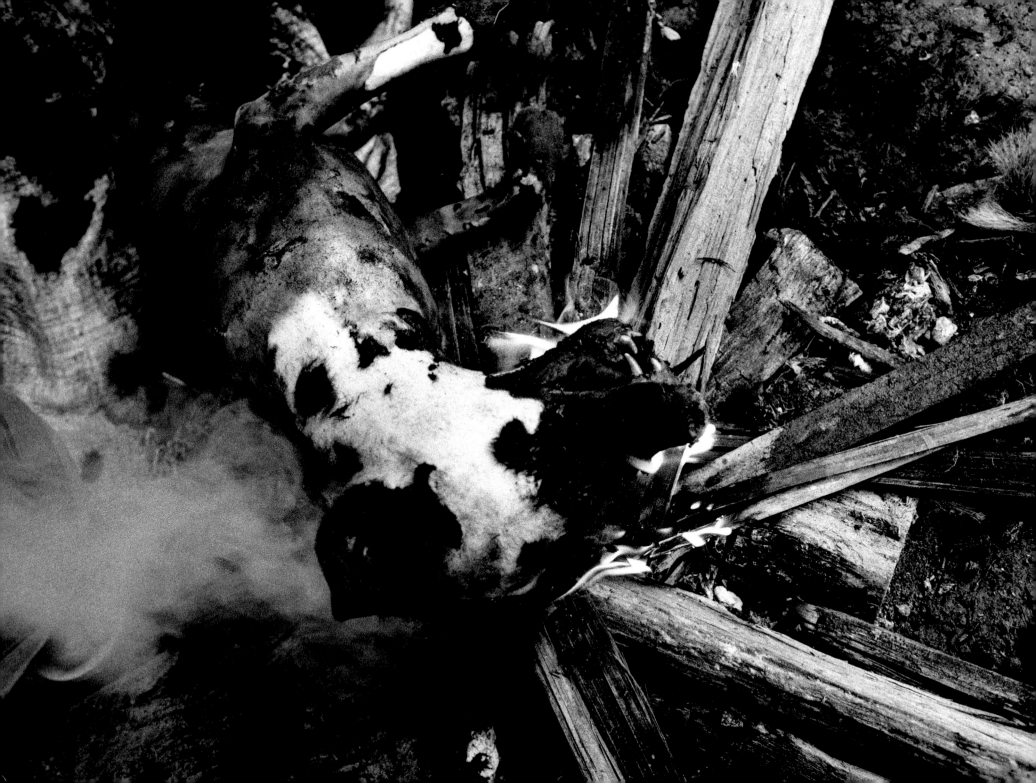

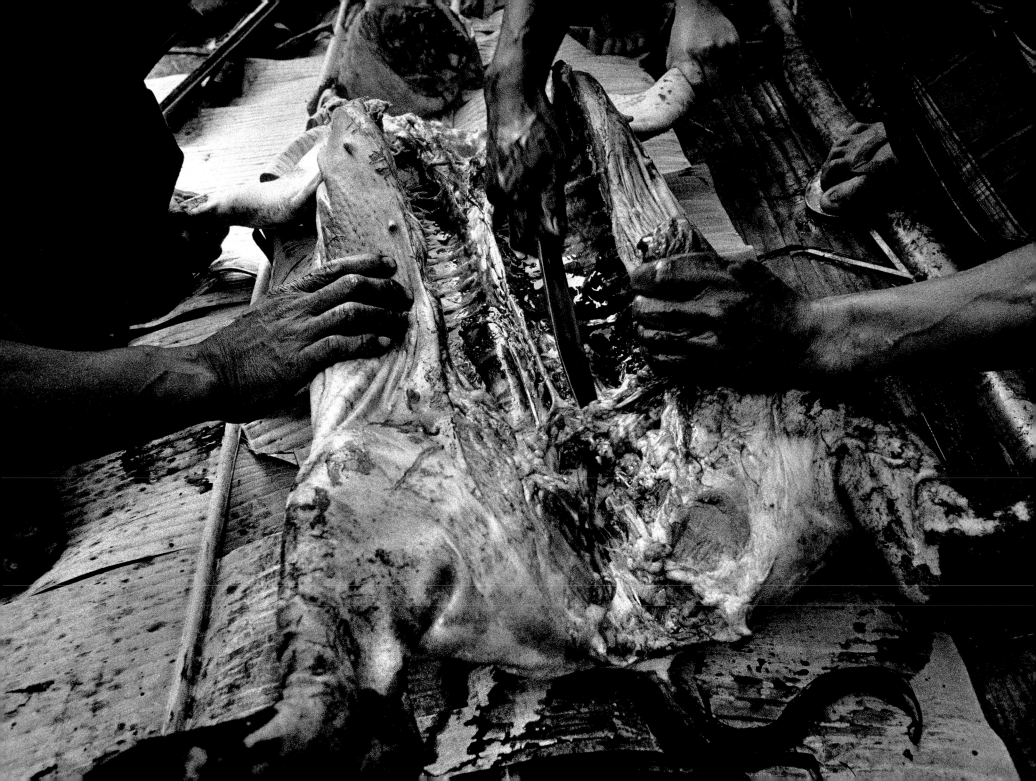

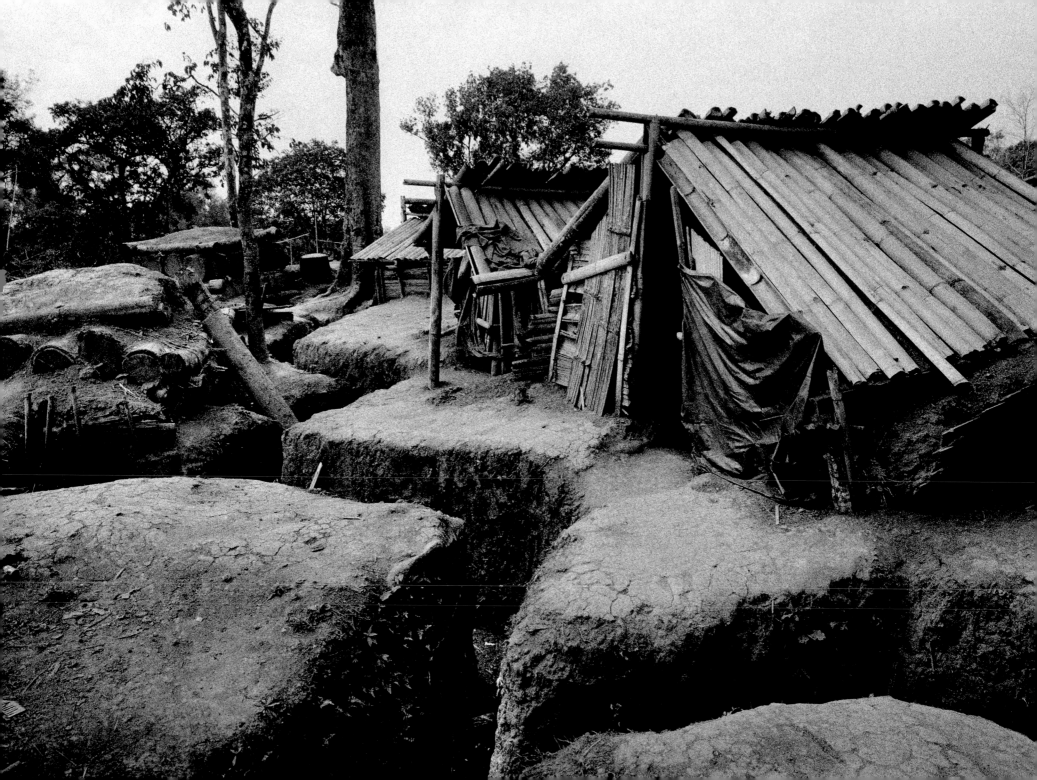

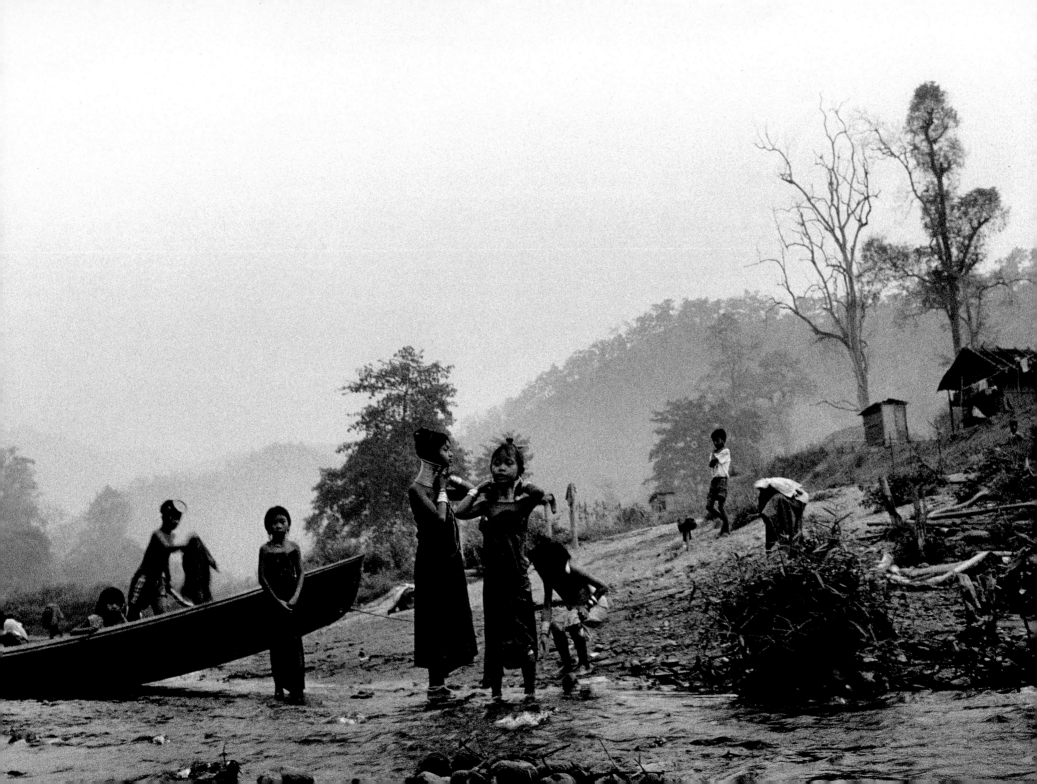

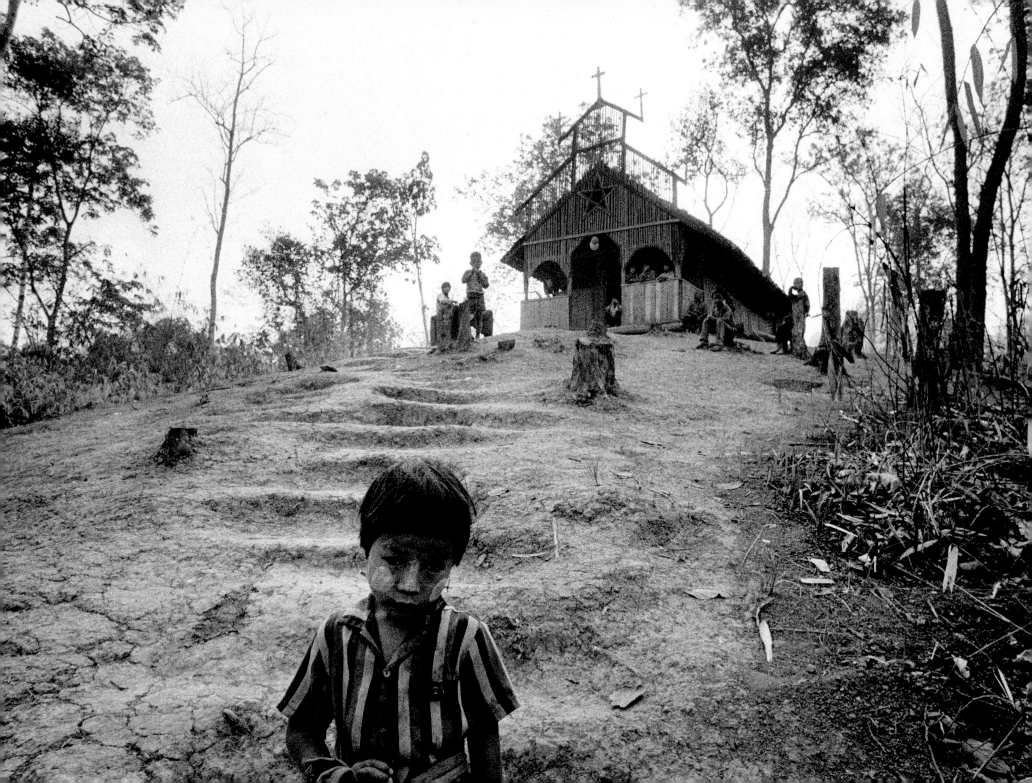

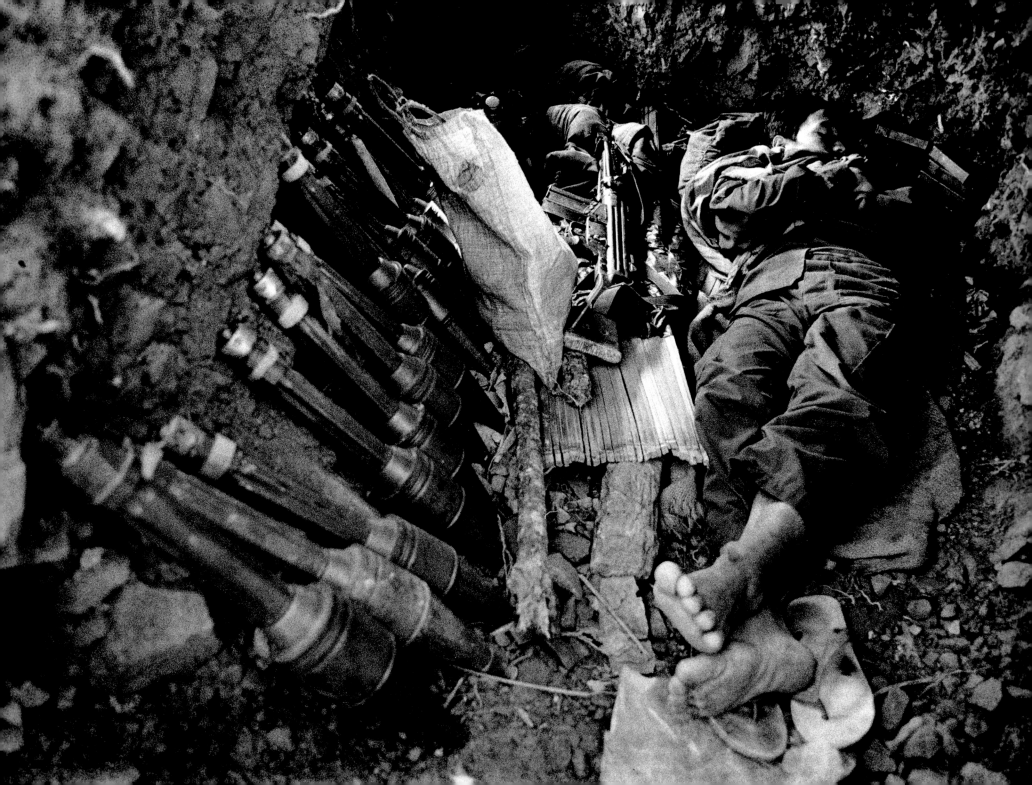

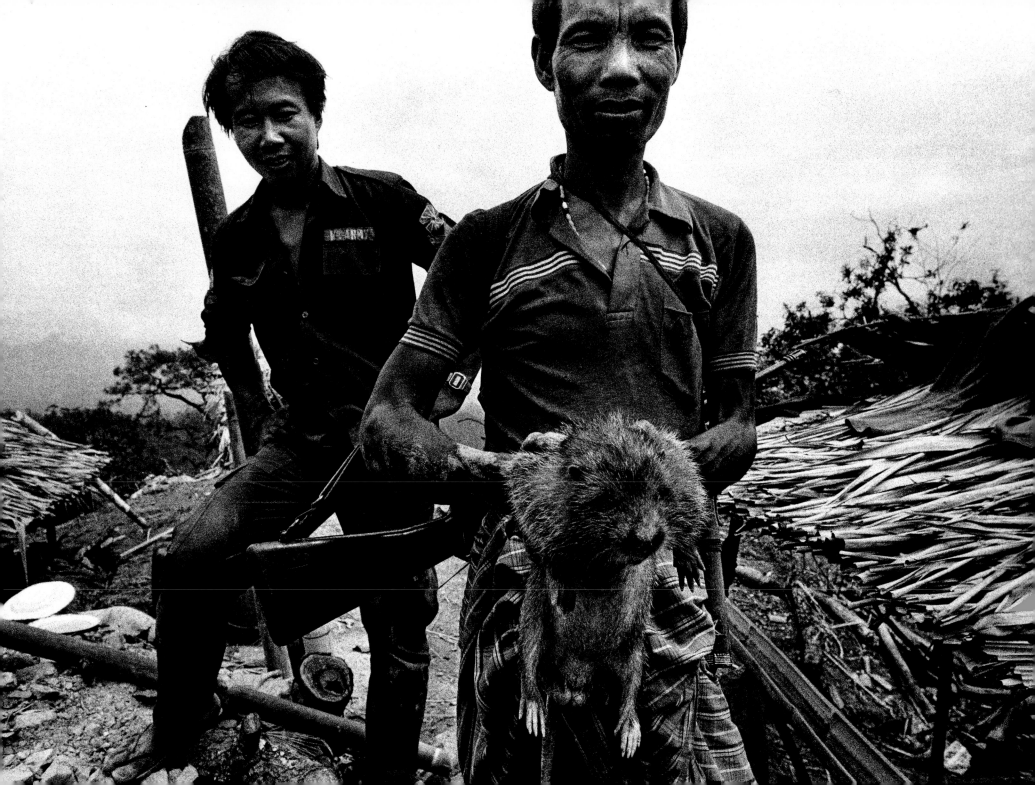

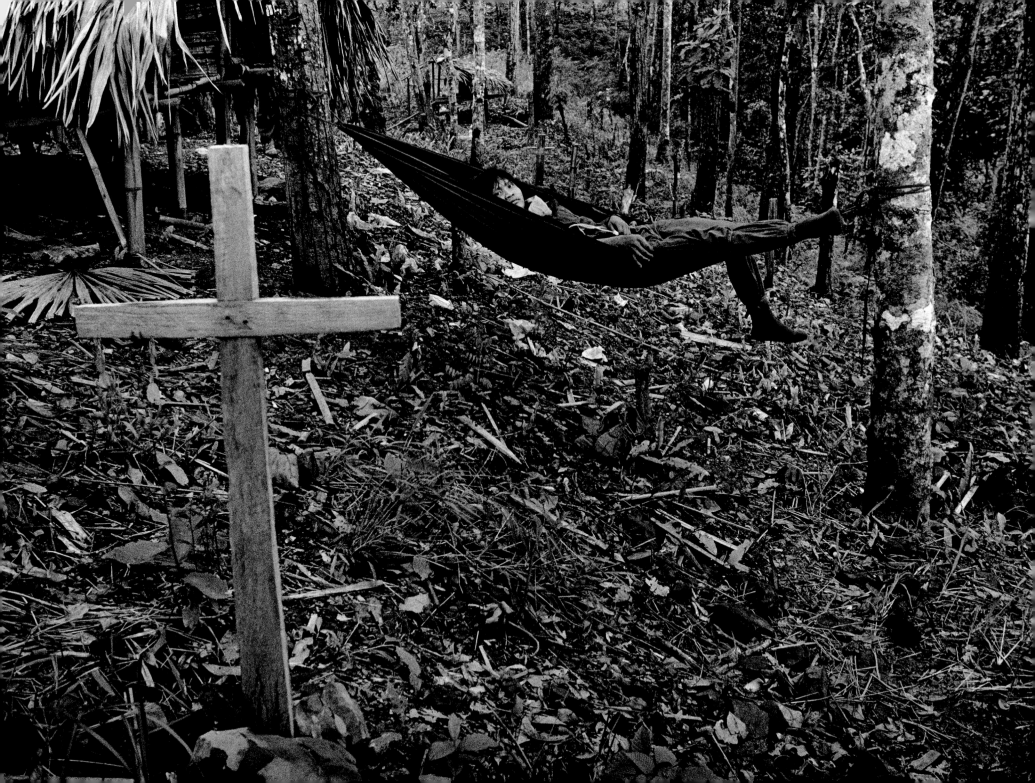

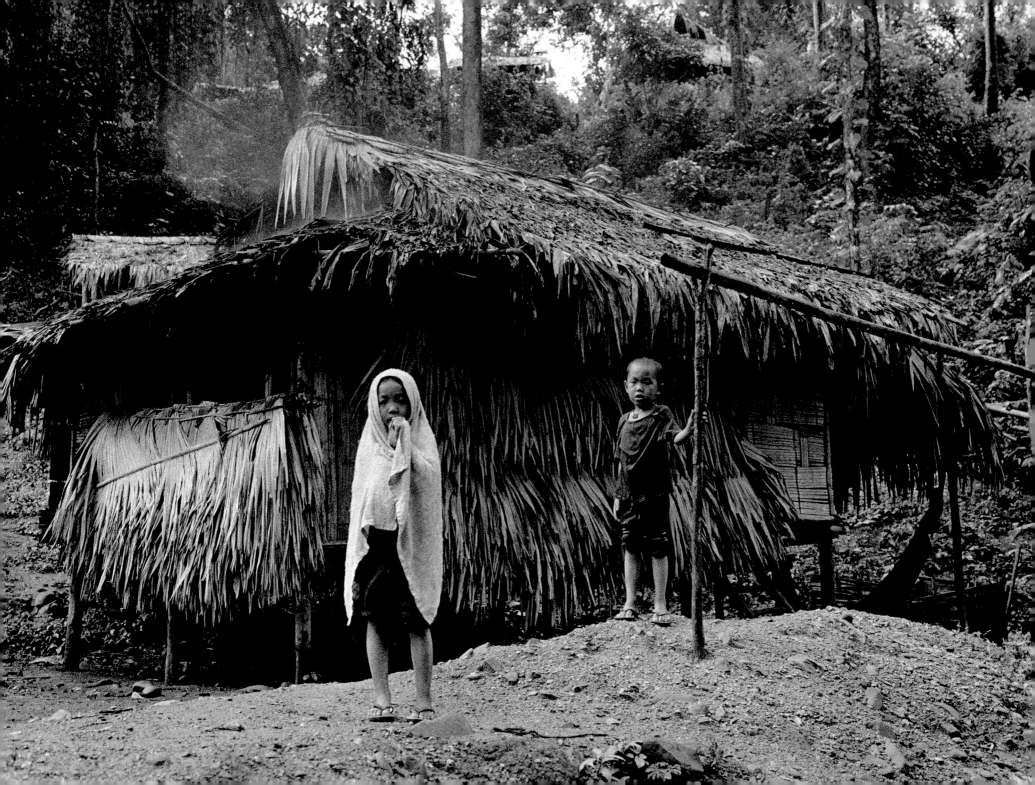

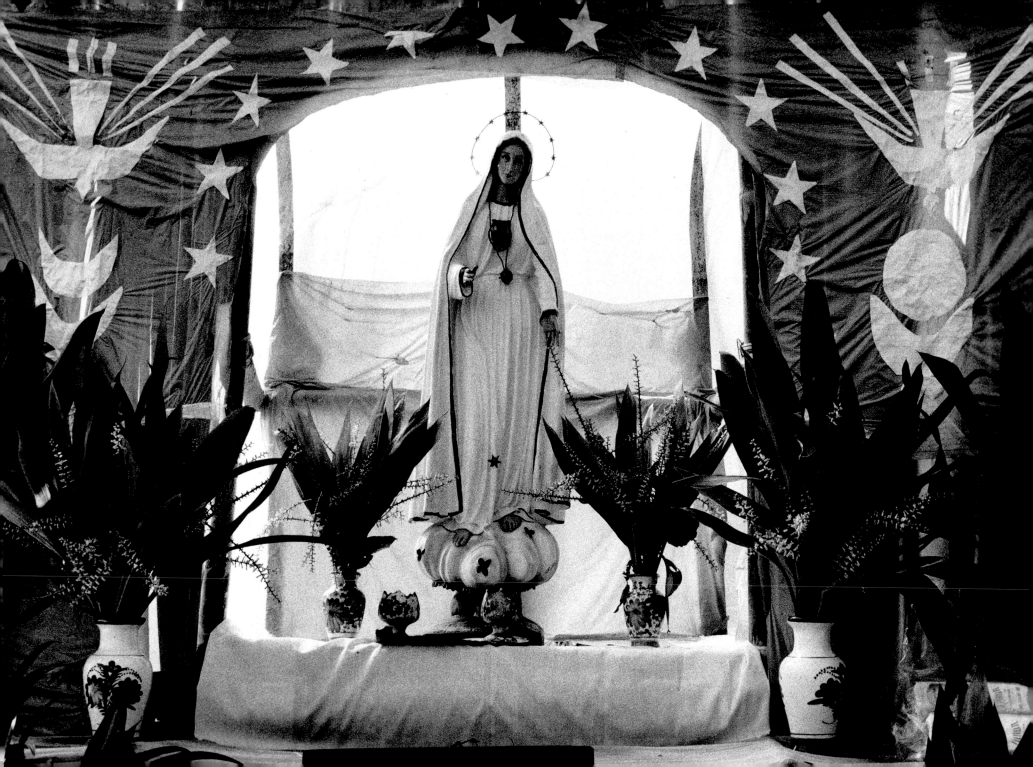

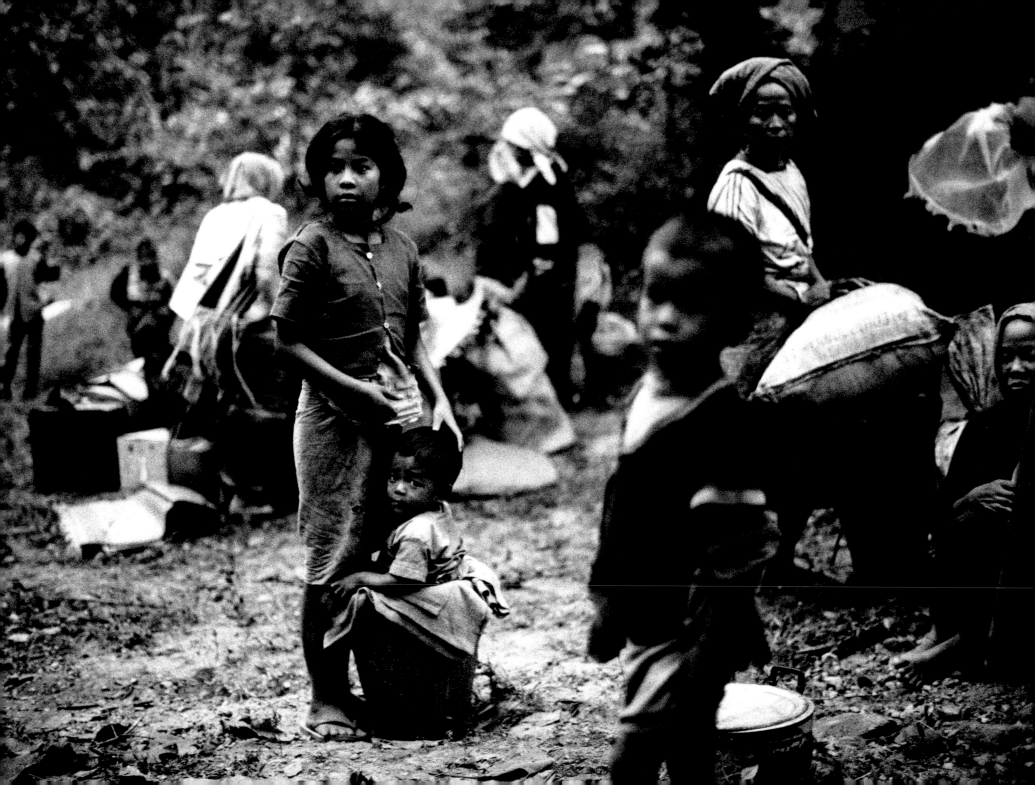

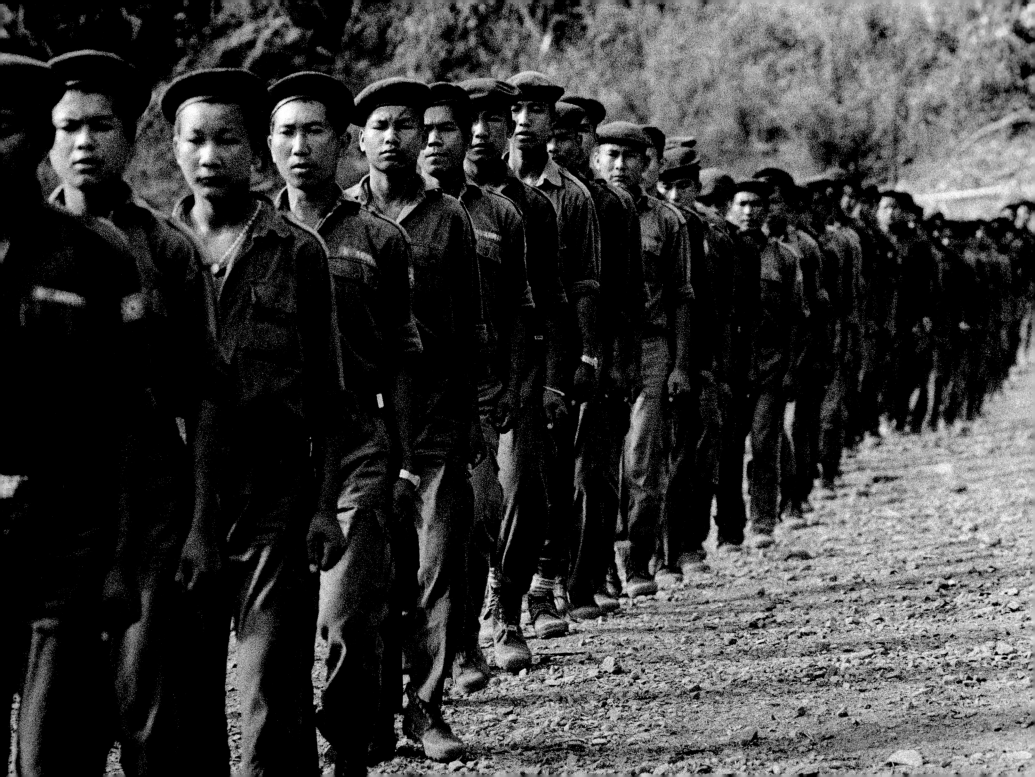

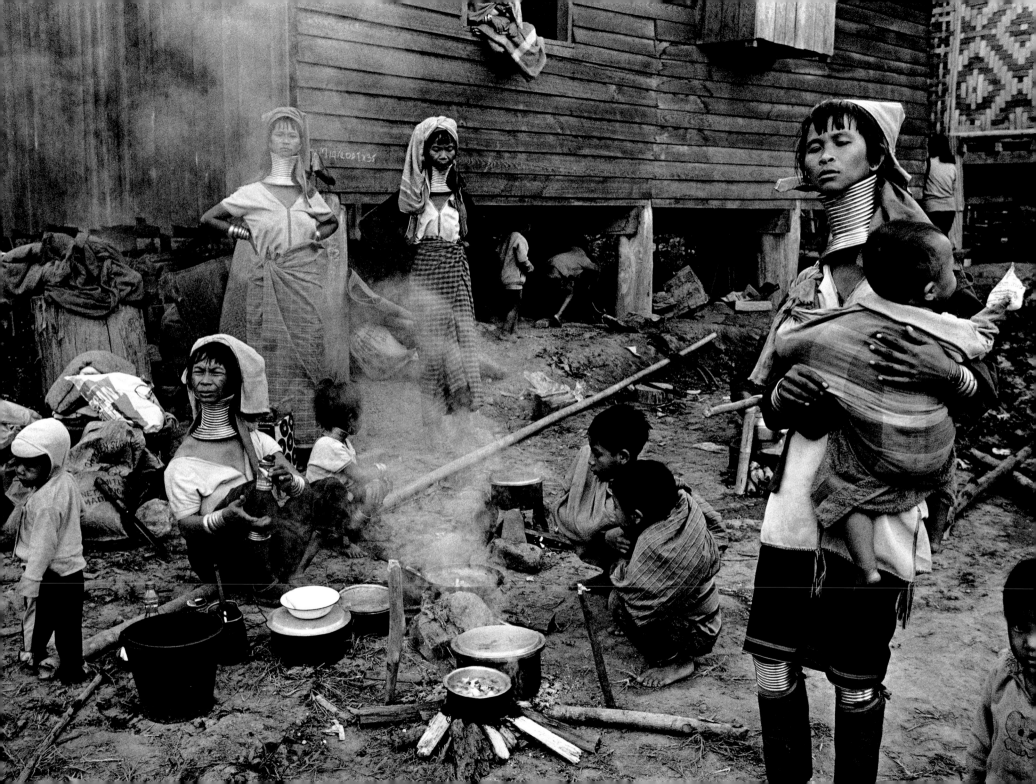

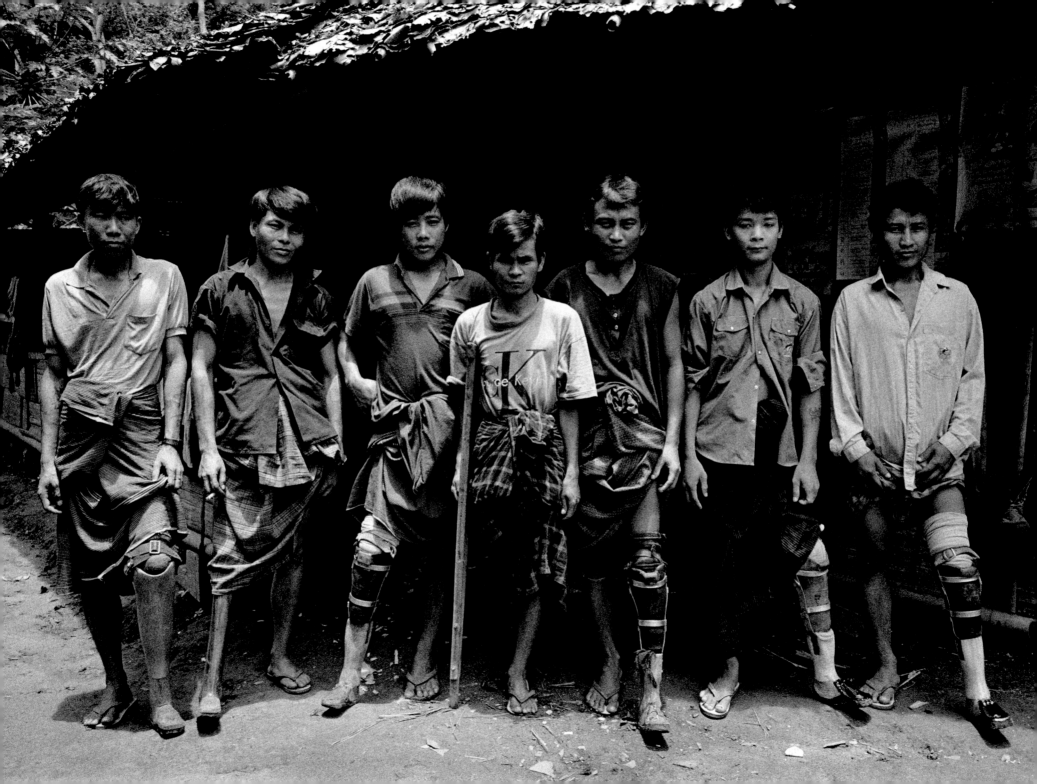

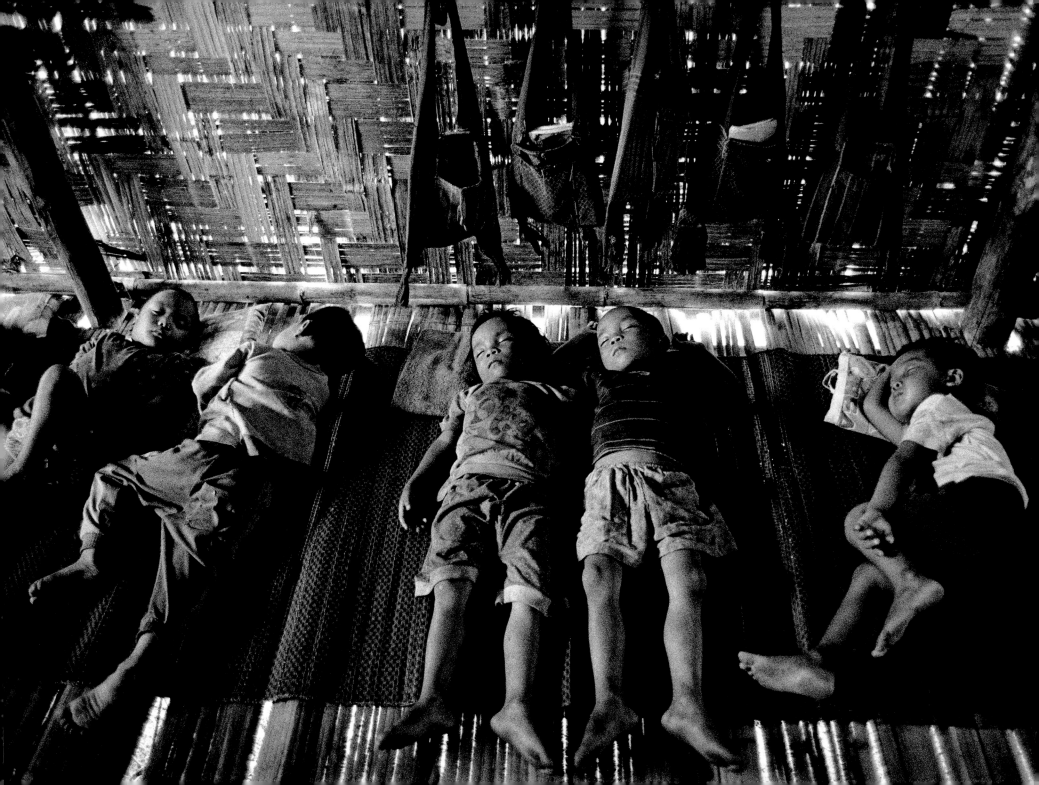

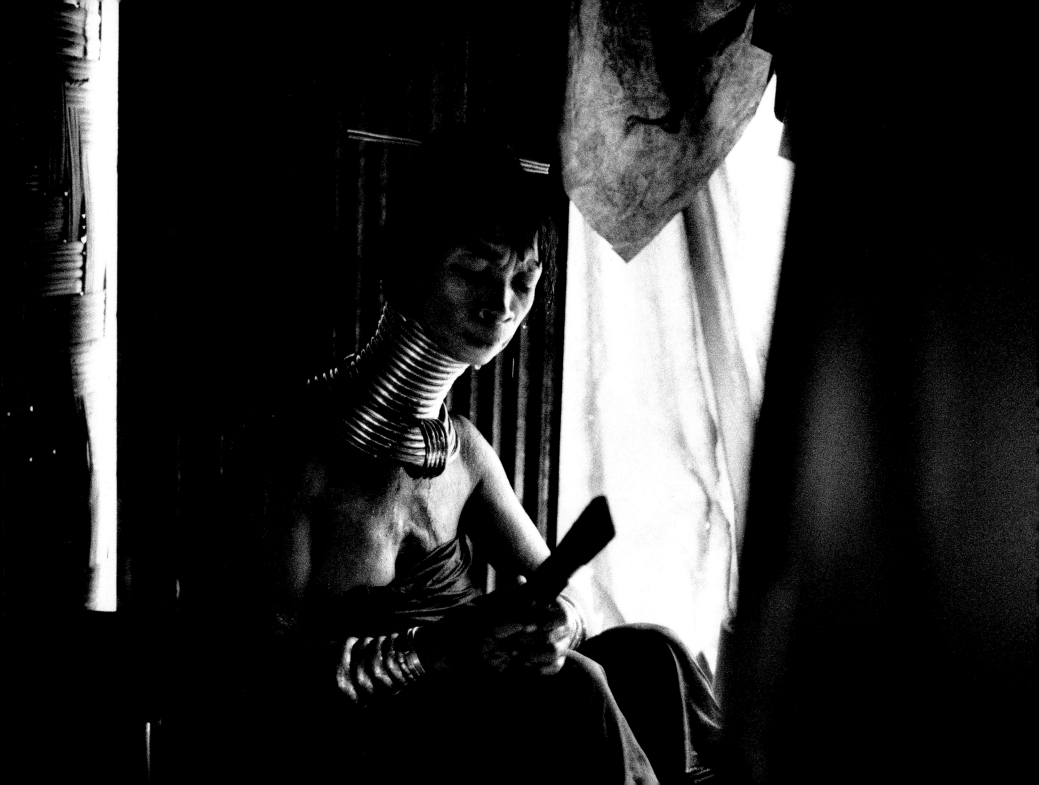

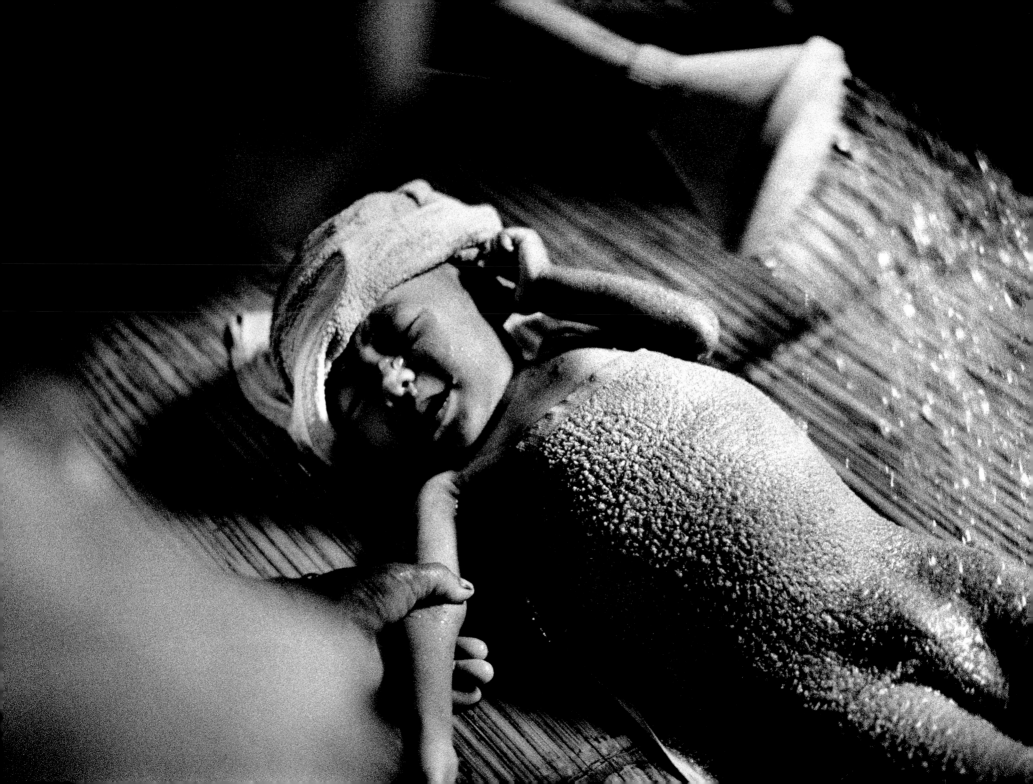

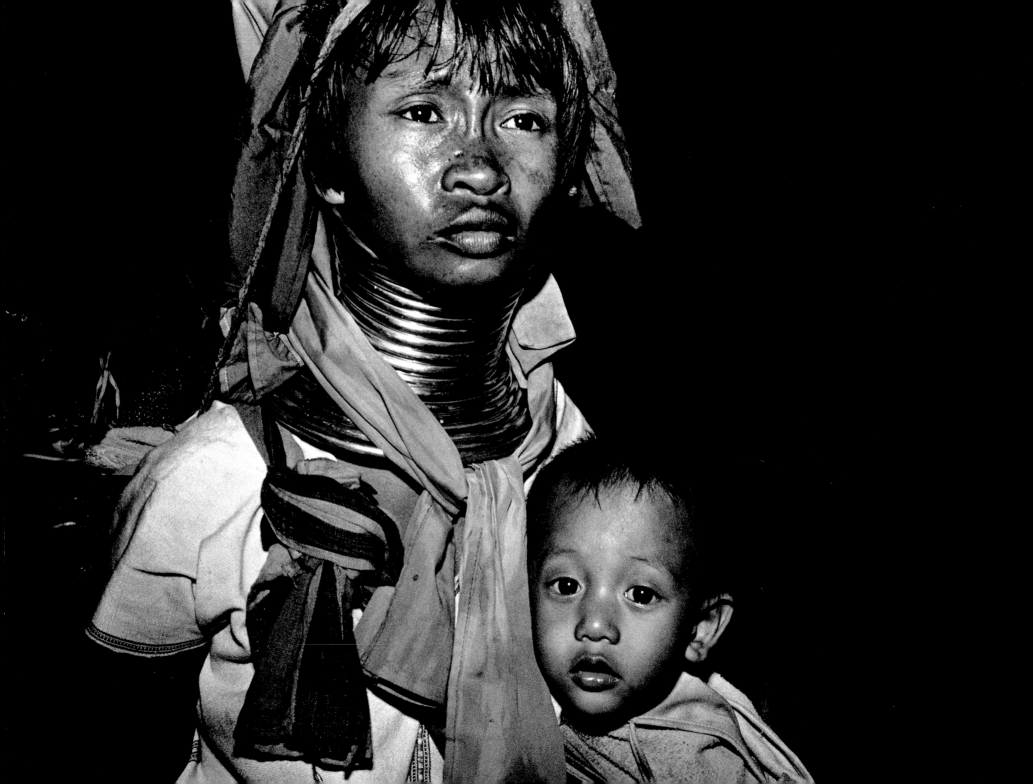

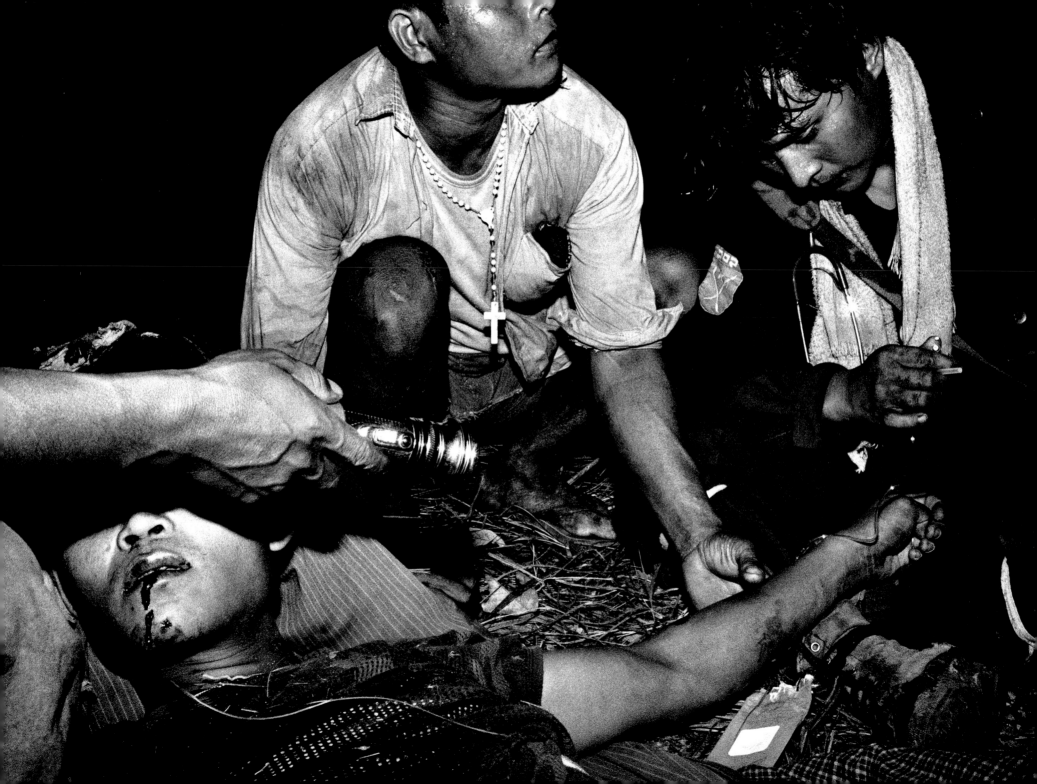

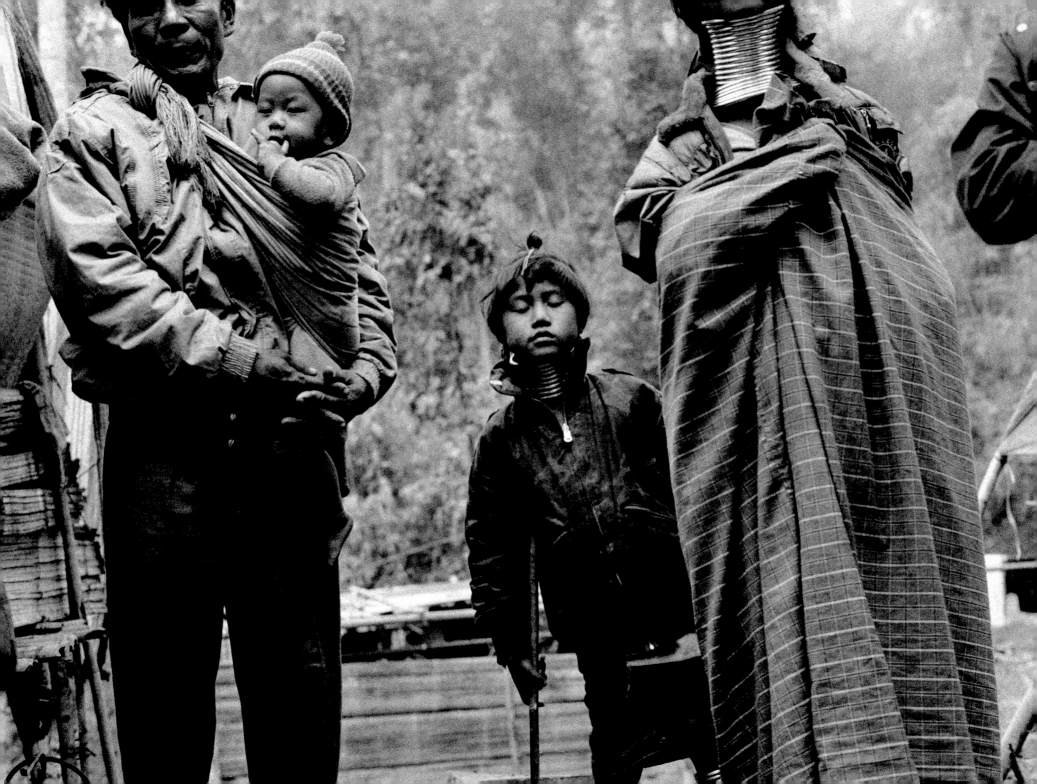

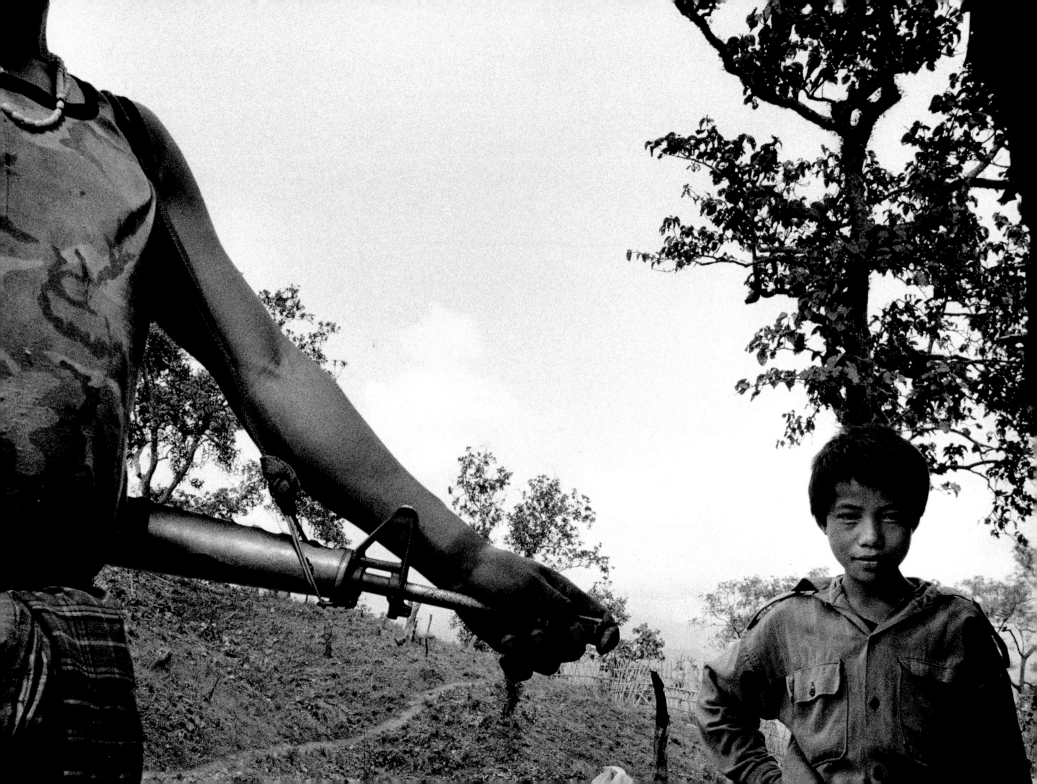

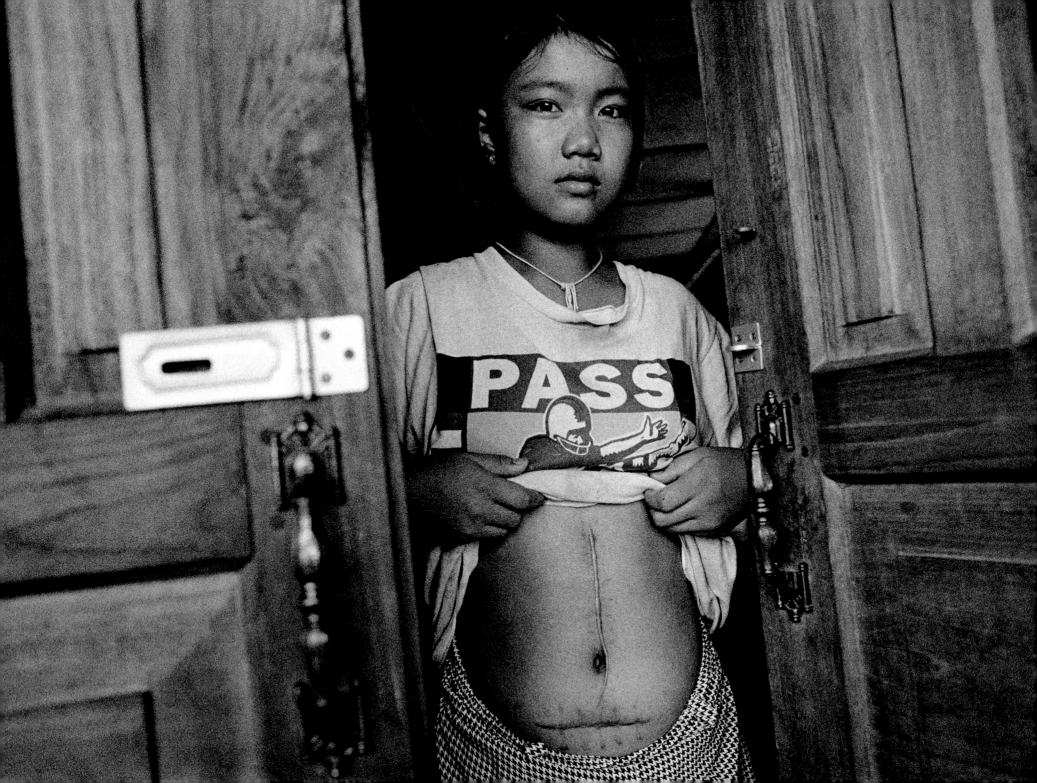

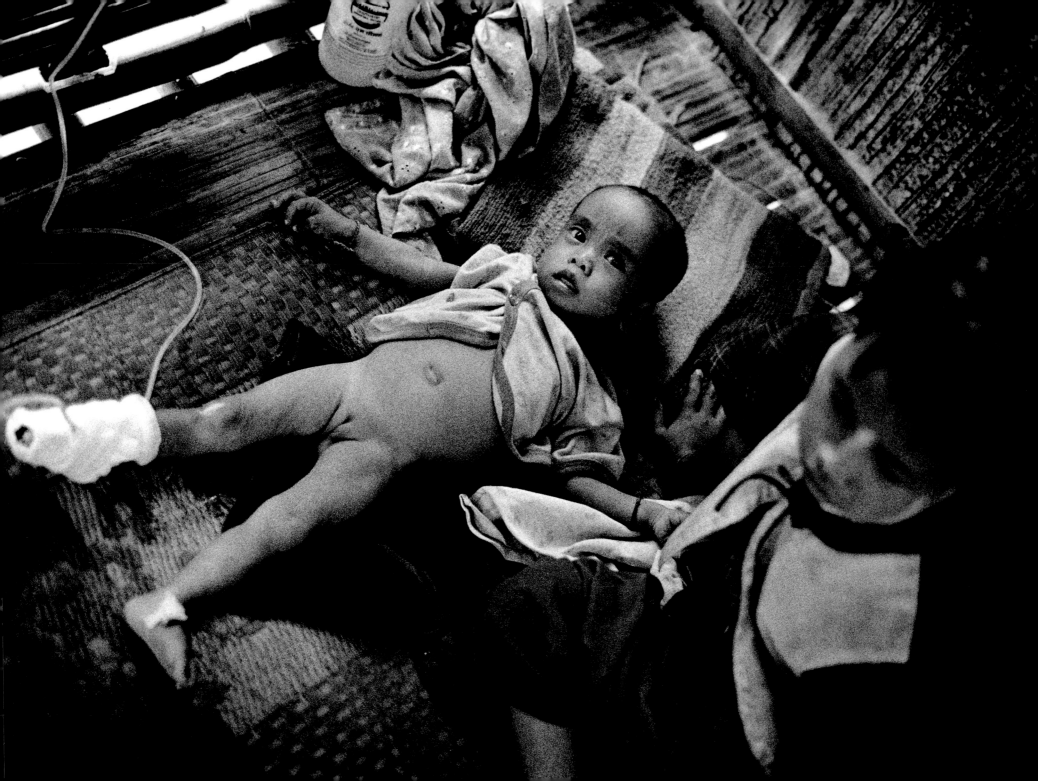

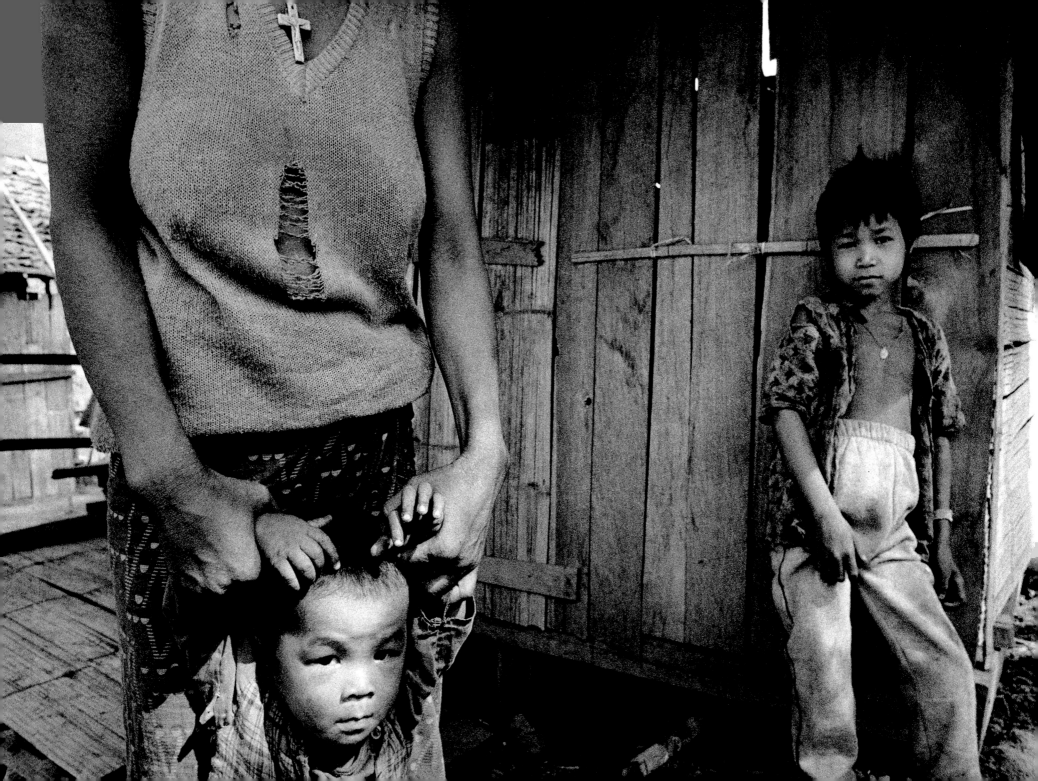

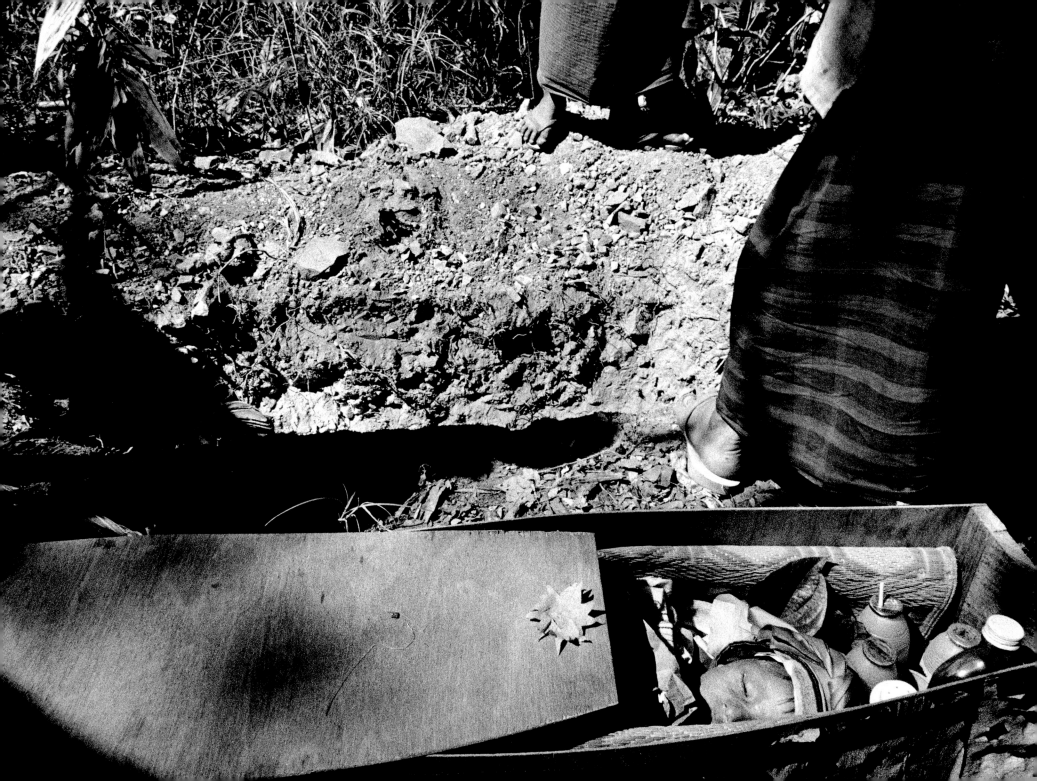

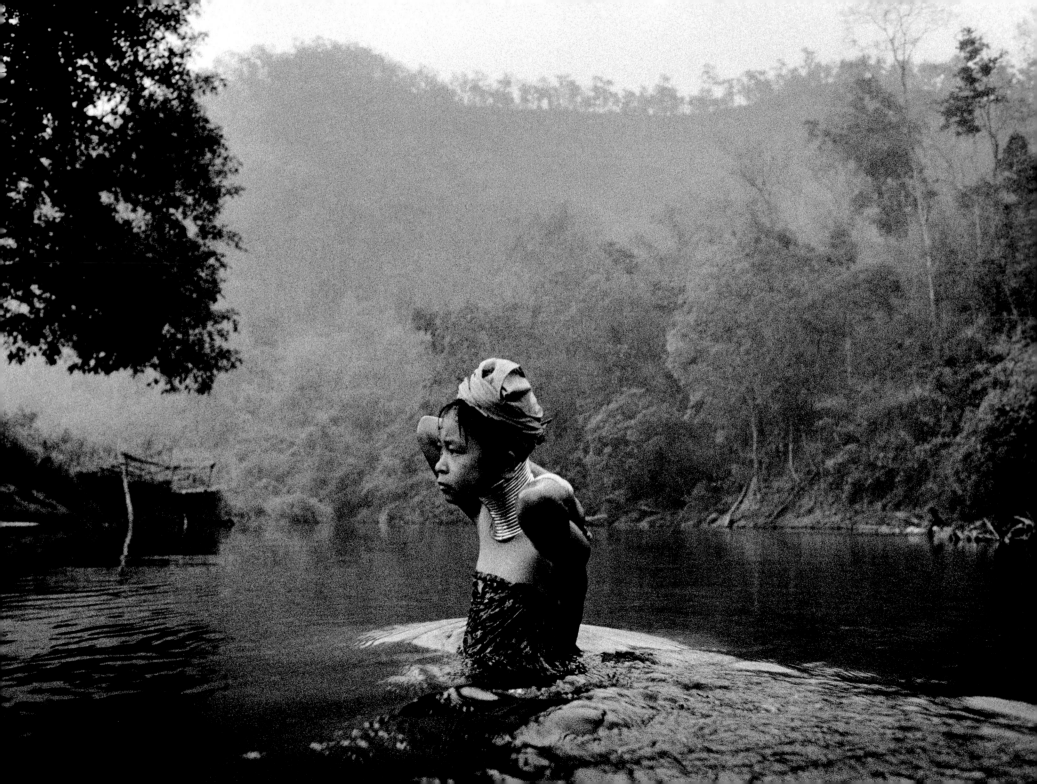

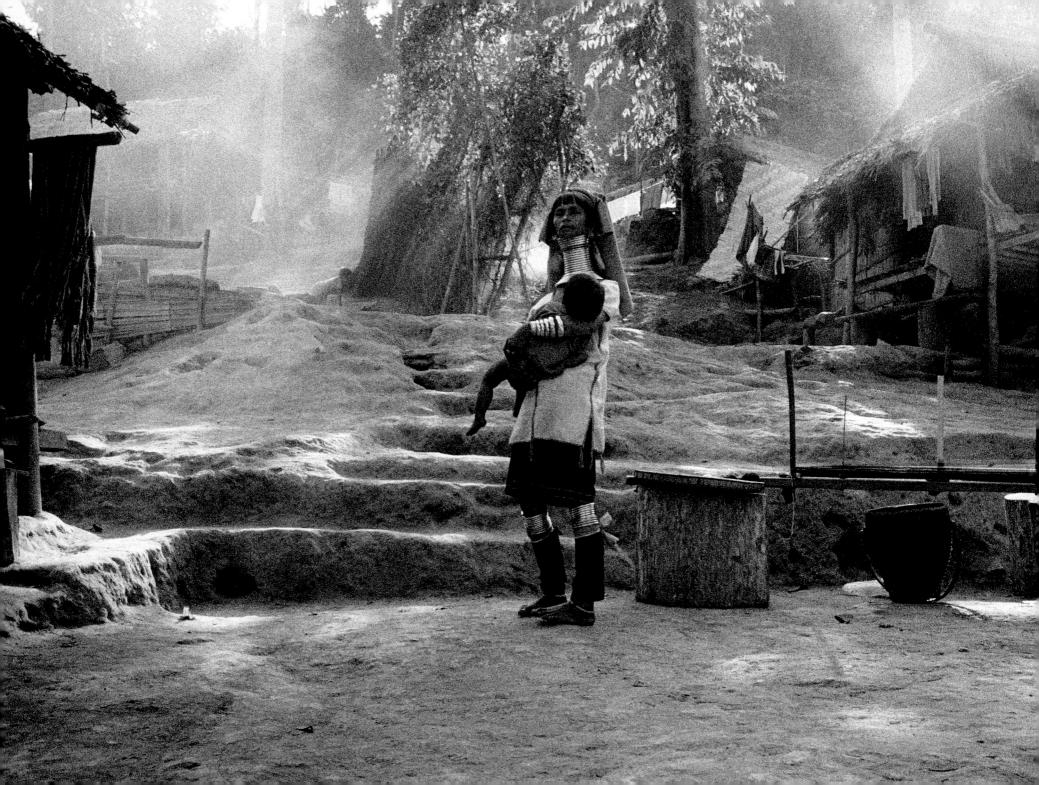

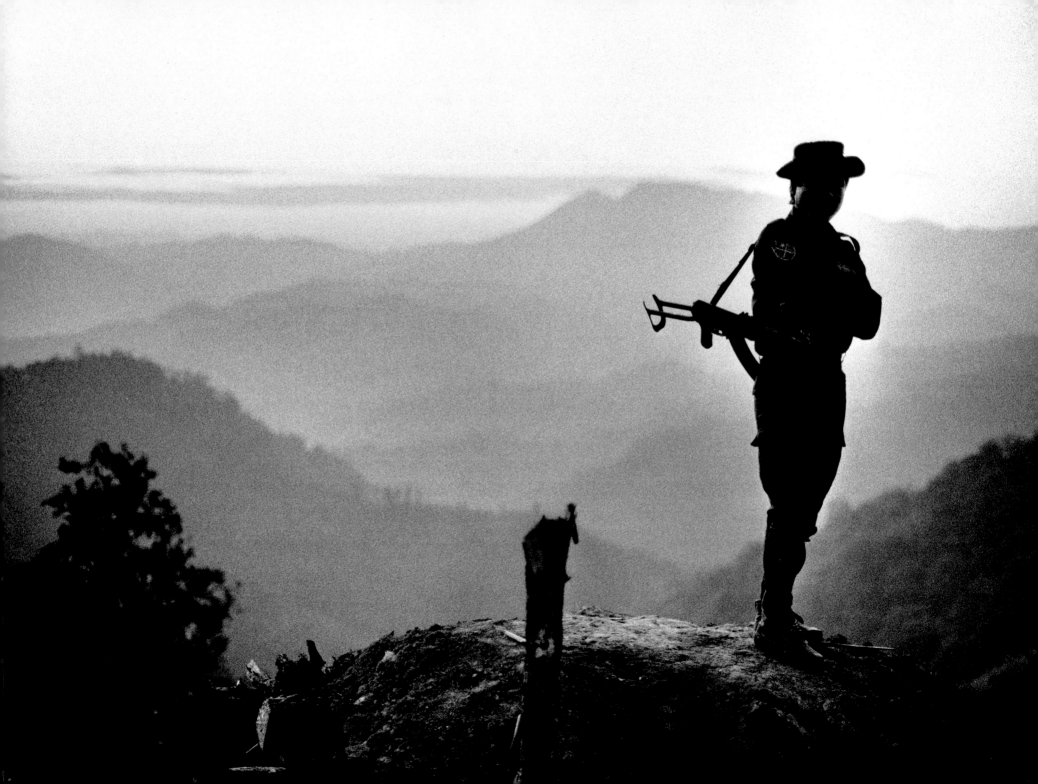

Captions

Reading the bones. The village shaman inserts baboo splints into tiny holes along the thighbone of a chicken. The alignment of the splints can give the shaman answers to questions that he has called on the spirits to answer. The rooster was killed by asphyxiation. Such sacrifices and predictions occur at all Karenni festivals, or when a villager chooses to consult the spirits.

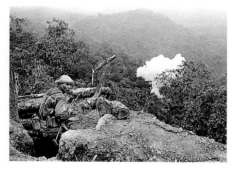

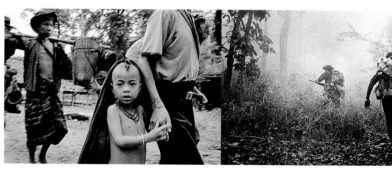

Early morning. A 120mm mortar shell explodes at the beginning of the second battle for Ember Hill. The ABSDF soldier was one of four young men who joined the student army after being forced to porter for the Burmese Army. They escaped by fleeing across minefields. He was later killed in action.

Kayah forced relocation victims arriving in Thailand, having chosen to flee rather than be forced at gunpoint into the 'safe camps' established by the Burmese authorities. The Burmese Army burned the villages, destroyed the rice stores and paddy, and shot the cattle of those who fled to Thailand.

Karenni soldiers heading for deployment around the Karenni capital, Loikaw.

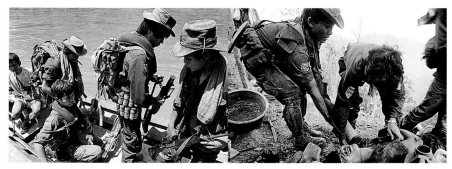

Pai River. Karenni soldiers leaving for the frontline in a long-tail boat. Fighting rages close by as Burmese Forces try to recapture an outpost recently overrun by Karenni forces.

An ABSDF soldier is hit in the back by shrapnel from a 120mm mortar shell. He noticed Burmese troops closing in on the position and had opened fire on them. The mortar shell slammed in behind him.

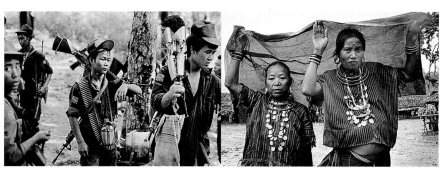

Exhausted Karenni Army trainees returning from the front line, carrying weapons from an arms cache threatened by advancing Burmese troops.

Kayaw women attending a ceremony to mark the Thai Queen's birthday. The ceremony was conducted by Karenni officials as a way of thanking Thailand for the refuge given to the Karenni people in Thailand.

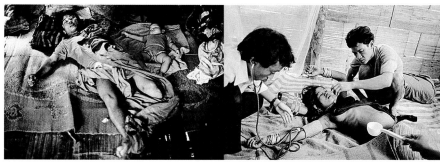

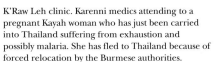

A Kayan man sleeping alongside his baby daughter, after mourning the death of his teenage stepson. The teenager had been hunting in the forest inside Karenni when he stepped on a landmine. Badly injured, he put the barrel of his rifle into his mouth and pulled the trigger. His companion heard an explosion and then a bang.

K'Raw Leh clinic. Karenni medics attending to a pregnant Kayah woman who has just been carried into Thailand suffering from exhaustion and possibly malaria. She has fled to Thailand because of forced relocation by the Burmese authorities.

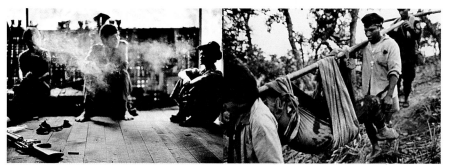

Karenni guerrillas in a rest camp having just returned from the front line.

A wounded ABSDF (All Burma Students' Democratic Front) soldier being evacuated from the front line during the second battle for Ember Hill.

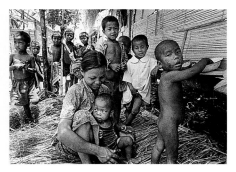

Kayaw mothers and boys.

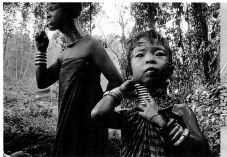

A Kayan boy swimming in floodwaters.

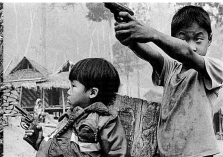

A Kayan girl cooling herself in the receding waters of a flash flood.

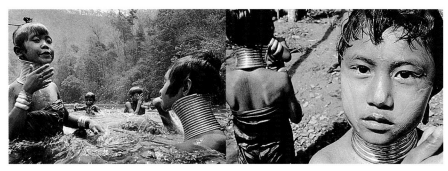

Kayan children bathing in the Pai River.

Kayan girls playing in the receding waters of a flash flood.

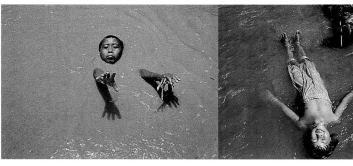

Kayan sisters washing at the village spring early in the morning.

Hot Season. Kayan boys playing at war.

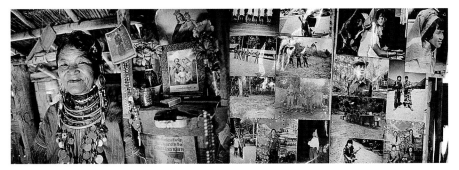

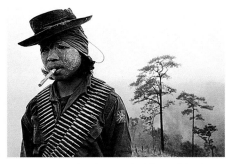

A Kayaw grandmother standing next to the Roman Catholic shrine in her home. She 'works' for the Karenni Culture Ministry in a village established for foreign tourists. As the Kayan are often referred to as the 'long-neck', Thai tour guides have dubbed the Kayaw women the 'long ears'.

Photographs in a Kayan home.

Tanna Kwae Point. A Karenni soldier awaiting the next Burmese Army offensive. Scattered around the position are scores of dead Burmese soldiers who failed to capture the position. The wind reeks with the gagging stench of death.

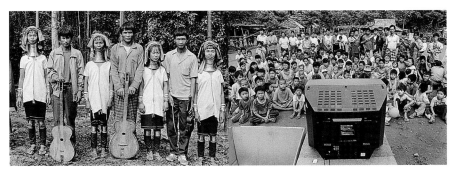

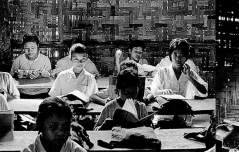

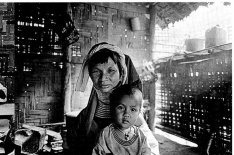

Kayan men and women attending the ceremony marking the 31st anniversary of Karenni Armed Forces Day: 17th August '92. Rambo Hill.

8th August '96. The 8th anniversary of the slaughter of thousands of civilians by the Burmese Army following the popular pro-democracy uprising across Burma. ABSDF and Karenni families about to watch a video, following a ceremony to remember those killed in the pursuit of democracy.

5th grade girls studying at the Karenni Government High School. Subjects include the Kayah, English and Burmese languages, mathematics, geography, history, and science. Instruction depends on the availability of teachers and funding.

Kayan mother with one of her four daughters, in their kitchen.

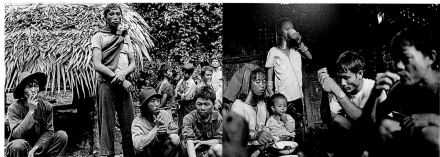

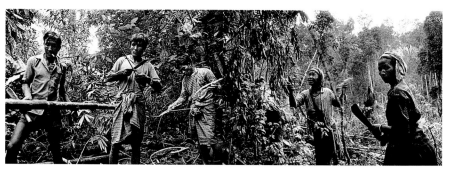

Shan men relaxing having escaped from the Burmese Army. Forced at gunpoint to carry munitions to the front line, these men had been away from their homes for two months. They escaped by crossing Karenni minefields. One Karenni officer joked that they must have been 'walking with angels' to come through unscathed.

Kayan family eating lunch in their kitchen. The woman and the men are drinking home-made whisky.

Kayan men cutting bamboo for the construction of a house.

Kayah women making a little money by clearing away the undergrowth for a teak plantation planned and financed by the Thai Ministry for Forests.

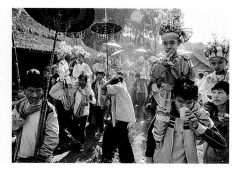

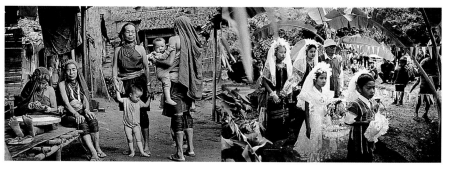

Shin Pyu festival. Ethnic Shan and Pa-O boys are being carried around the refugee camp prior to the novitiation ceremony where the boys become Buddhist monks. The celebrations leading up to the ceremony lasted for four days and nights.

Kayah women and children adapting to life in a refugee camp after fleeing forced relocation by the Burmese authorities. The Burmese Army burned their village as punishment for fleeing to Thailand. The Thai authorities are reluctant to allow foreigners access to this camp which is close to the Karenni frontier and Burmese troops. Many refugees live in fear of one day being forcibly repatriated into the arms of the Burmese authorities, regarded as a foreign power and the enemy.

Karen Baptist wedding. Shortly before the refugee camp was relocated by the Thai authorities.

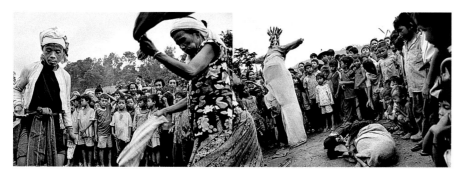

A Kayah man (left) dressed as a woman, dancing during the Di Khu Pwae (sticky rice) festival. The festival is held in August or September depending on the spirits, and celebrates the planting of the rice paddy.

Spirits dancing, playing and teasing during the Di Khu Pwae (sticky rice) festival.

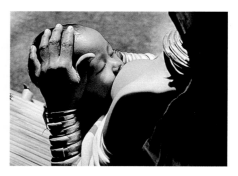

A Kayan woman breast-feeding her baby son. Tourists visiting the Kayan village often hand out candy to the children and as a result this boy's front teeth have since failed to develop.

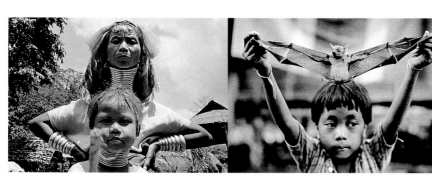

Kayan mother and daughter.

A Kayan boy with dinner; a bat shot by his father with an ancient musket.

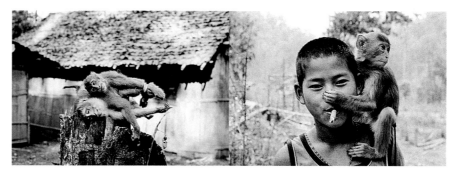

Monkey meat for sale. 80 baht per monkey ($3).

A 15 year-old Karenni Army trainee with his pet monkey.

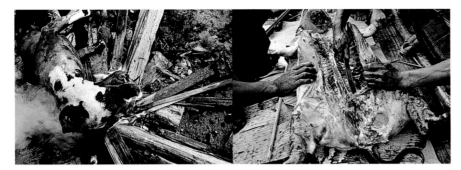

Butchering a dog for dinner. Traditionally, the Kayan believe that they must eat dog meat once in the cold season for medicinal purposes. The dogs are beaten to death. The meat of the dog is often minced then mixed with chillies and stuffed into the washed intestines to make sausages. Many Kayans choose not to eat snake or frog meat as they regard the animals as dirty.

Butchering a pig. A Kayan child has died from malaria and a meal is prepared for the wake of the child. The pig's head was left on top of the child's grave after an animist burial.

Na Lone Checkpoint. A Karenni Army position close to the Thai border.

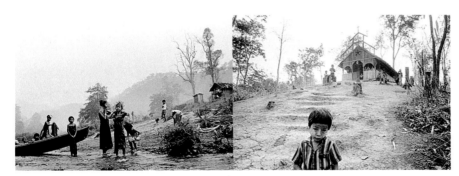

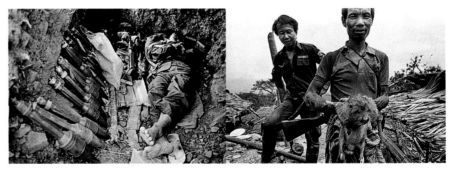

Hot season. Early morning. Kayan girls washing in the Pai River.

Easter. Roman Catholic Church.

Ember Hill. Karenni guerrilla sleeping in a bunker with a Burmese Army rifle and rocket propelled grenades.

Point Five Hill. Karenni soldiers with dinner – a bamboo rat.

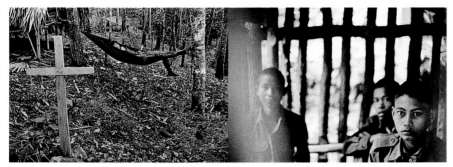

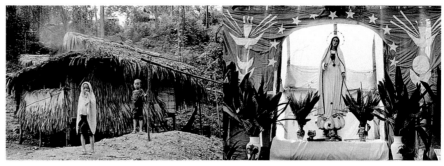

Rambo Hill. A Karenni guerrilla relaxing in a cemetery.

Prisoners of War. Burmese soldiers captured when the Karenni forces overran their outpost close to the Thai border. Twenty seven Burmese soldiers were captured. Thirteen survived. Of those, four decided to join the Karenni Army while the nine others were repatriated by a Thai NO. When Burmese troops reentered the outpost, dozens lost legs after standing on landmines, or were injured by booby traps left by Karenni forces.

Children standing in front of their home.

Christmas. Temporary Catholic Church.

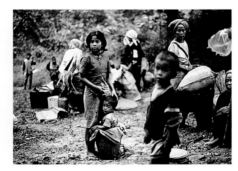

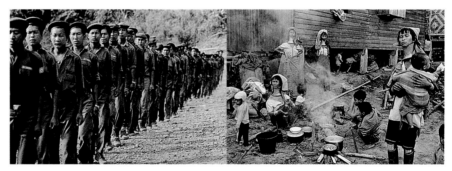

Early morning. Kayaw refugees waking after spending the night sleeping rough in the forest. The previous day, mortar shells fired by the Burmese Army during their offensive to capture the Ember Hill area began to land in Karenni refugee camps along the Thai border, forcing the refugees to flee further into Thailand.s

Karenni Army training camp.

Kayan women cooking breakfast the morning after fleeing deeper into Thailand from their refugee camp because of fighting along the border and the threat of shelling by the Burmese Army.

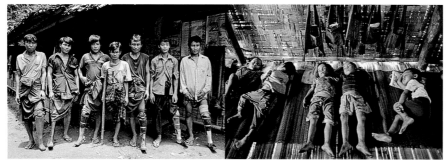 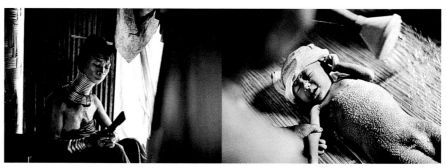

Amputees at a workshop making artificial limbs for themselves. All but the man on a crutch were Karenni combatants and some lost limbs after standing on mines laid by Karenni forces.

Afternoon rest. Identical twins sleeping in a Karenni Government nursery.

A Kayan woman enduring a sauna as a means of cleansing her body after giving birth. The sauna lasted for three days, during which her amputee husband heated rocks on an open fire. The rocks were placed beneath the woman who would pour cold water on to them.

A malnourished Kayaw child suffering from malaria and running a dangerously high temperature is cooled using water poured from a watering can over a towel. The child is a victim of forced relocation by the Burmese authorities.

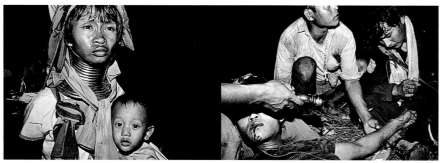 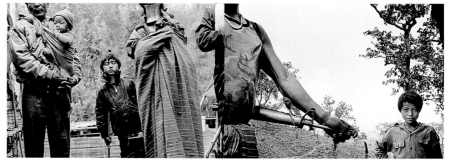

Kayan mother and son fleeing further into Thailand because of a Burmese Army offensive spilling over the border into Thai territory.

An ABSDF medic monitoring the intravenous drip given to a wounded student soldier who is being evacuated from the front line.

Cold Season. Morning. A Kayan family warming themselves around an fire.

Rambo Hill. Young Karenni soldiers.

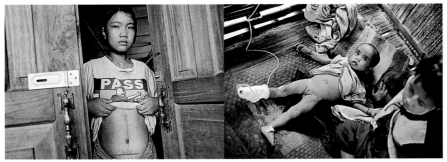

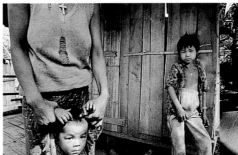

The 11 year-old daughter of the Karenni Religious Affairs Minister displaying the scars from operations she underwent after being shot through the stomach in a failed assassination attempt on her father's life by Burmese agents inside Thailand.

A malnourished 4 year-old girl in a Karenni Government clinic. A recent arrival after fleeing forced relocation.

A Kayaw boy with a clubfoot being helped to walk by his mother. His mother died shortly afterwards and his brother was left to look after the handicapped child. They were subsequently adopted by another family.

Rambo Hill. The animist burial of a Kayan child who died from malaria.

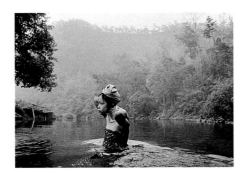

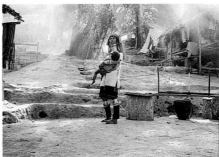

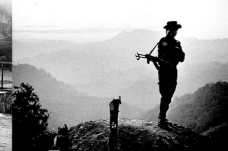

A Kayan woman washing in the Pai River.

Cold season. Sunlight burning through morning fog. A Kayan woman carries her sick daughter, shortly before she died from malaria.

Sunset. Ember Hill. An ABSDF soldier standing guard on a bunker in front of Elephant Mountain. Another Burmese offensive is expected.

Photographic Prints
Michael Spry
Downtown Darkroom - London

Design
Donatella Pistocchi

Layout
Fulvio Forleo

Paper
Ikonofix Special Matt - Zanders

Reprographics
SCROI Società Cooperativa Riproduzioni Offset Italia

Print
Prostampa Sud Grafica Editoriale
Santa Palomba (Rome)